PAINT & PAINTING

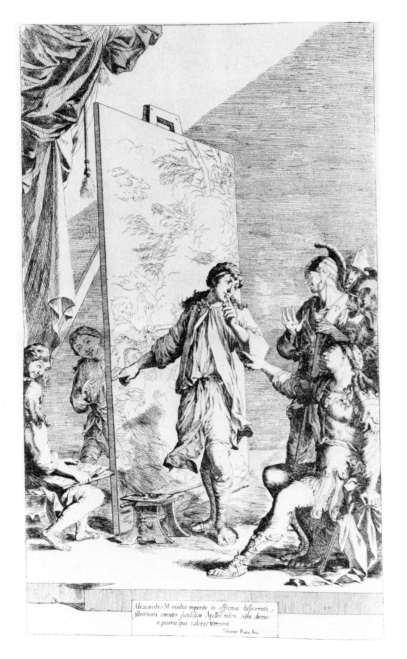

Alexandro M. multa imperite in officina differenti,
silentium comiter suadebat Apelles radere cum diceret
a pueris qui colores tererent

Salvator Rosa Inv.

After Salvator Rosa 1615–73
Alexander the Great in the Studio of Apelles

Engraving from 'Serie di 85 Disegni,
Antonio Casaletti, Rome 1780'
Witt Print Collection 45.5 × 27.2

The incident shown in the engraving derives
from Pliny the Elder's *Chapters on the History of
Art*. Apelles dissuaded Alexander from talking
about art in case the young colour grinders in his
studio should laugh at him.

PAINT & PAINTING

An exhibition and working studio sponsored by
Winsor & Newton to celebrate their 150th anniversary

The Tate Gallery

ISBN 0 905005 68 6
Published by order of the Trustees 1982
for the exhibition of 9 June–18 July 1982
Copyright © Winsor & Newton/The Tate Gallery
Published by the Tate Gallery Publications Department,
Millbank, London SW1P 4RG
Designed by Sue Fowler
Printed by Balding + Mansell Limited, Wisbech, Cambs

The catalogue has been compiled by Lynda Fairbairn
for Richmond Towers Public Relations, London
and produced with the generous financial assistance
of Reckitt & Colman plc

'Paint & Painting' has been organised by the
Tate Gallery and Winsor & Newton, who have also
sponsored the exhibition
Exhibition designed by Paul Williams
Exhibition graphics by Philip Miles
Photography by Chris Steele-Perkins
The working studio designed by Alan Stanton

Contents

Cover
John Singer Sargent 'Claude Monet painting at the edge of a Wood' *c.*1887 (detail)

Foreword

At the Tate Gallery, we have for a long time been aware of a growing interest on the part of the public in how works of art are made and in the materials used by artists. It therefore gave us great pleasure when the possibility of showing an exhibition devoted to the history and production of artists' materials, and their use as illustrated by paintings in the Tate collection, became a reality thanks to generous sponsorship from Winsor and Newton. The opportunity offered to the public of testing these materials in the Working Studio and of obtaining advice and guidance in their use will be immensely valuable to trained and untrained painters alike.

Our warmest thanks are due to Winsor and Newton for this splendid gesture towards the Tate and its visitors on the occasion of the company's 150th anniversary. I would also like to thank the Winsor and Newton Public Relations advisers, Richmond Towers, and in particular Lynda Fairbairn and Roger Jupe, who have co-ordinated all aspects of the exhibition and Working Studio.

The work in the exhibition, selected by Lynda Fairbairn and Stephen Hackney of the Tate Gallery, include loans from the Royal Academy of Art, the Courtauld Institute of Art and private collectors.

Invaluable help in the preparation of the exhibition has been given by the staff of the British Library, The Courtauld Institute of Art and the Witt Library; the Royal Academy of Art, the Colour Library at the Royal College of Art, and the University of London Library. The paintings on loan from the Courtauld Institute have been restored by Isobel Horovitz and Paula De Christofaro from the Technology Department at the Courtauld Institute. Pigment analysis of these paintings has been carried out by Gerry Hedley. Full technological investigation of the paintings from the Tate Collection have been carried out by the staff and students of the Conservation Department at the Tate Gallery. Gill Ford undertook the job of typing the catalogue.

We are grateful to the painters Valerie Archer, Lyndsey Bartholomew and Eric Waugh for practical advice and assistance in organising the Working Studio and to Laurence Bradbury for general advice on the Working Studio and lecture programme.

This catalogue has been compiled by Lynda Fairbairn and includes contributions from Mary Beal, Nicholas Eastnaugh, Stephen Hackney, Ben Read, Peter Staples and Caroline Villers.

We hope that this first instance of co-operation on a substantial scale between the Tate Gallery and a major industrial company will be the successful forerunner of many other joint projects.

Alan Bowness, Director

Winsor and Newton

The partnership formed by William Winsor and Henry C. Newton 150 years ago created a company whose name is today synonymous with fine art materials throughout the world.

In 1832 both men were in their late twenties and shared a common interest in painting. Newton was the more artistically gifted of the two whereas Winsor, who also painted, contributed the scientific knowledge that was to guarantee their success as artists' colourmen. They established their firm at 38 Rathbone Place, London, which was then part of an artists' quarter where a number of eminent painters, such as Constable, had studios.

From the start the company sought to improve significantly the quality of artists' colours by being aware not only of the needs of the painter but also of the colourman's responsibilities, in particular in respect of stability and permanence.

The improvement of artists' watercolours was the partners' first concern; they utilised the moisture-retaining properties of glycerine to manufacture watercolours in pans that were much simpler and more convenient to use than the watercolour cakes previously available.

Moist watercolours quickly earned a well-deserved popularity. Their next innovation was the introduction in 1837 of Chinese white, a particularly opaque form of zinc white, that was of considerable benefit to painters in watercolours who had lacked a durable, opaque white.

The partners did not limit their activities to watercolours. Winsor's inventiveness led him to introduce and patent glass syringes as oil colour containers to supersede skin bladders. This was in 1840 but, following the invention of collapsible metal tubes for artists' colours in 1841, Winsor embarked on the manufacture of tubes to his own design. Tin tubes were very quickly accepted as containers for oil colours and a few years later they were also used for watercolours.

The partners acquired premises at Blackfriars and at King's Cross but, in 1844, they dispensed with these in favour of a specially built, steam-powered factory at Kentish Town known as the North London Colour Works.

Their interest in the permanence of colours had never flagged. A number of the pigments they used were purchased from George Field, the most eminent English colour-maker of the early nineteenth century, who specialised in the manufacture of lake pigments but strove for maximum purity and permanence in all artists' pigments. It is hardly surprising that Winsor and Newton, who were completely identified with these ideals, should have been the artists' colourmen who first published the composition and permanence of their colours.

Recognition came quite early on in the form of their appointment as artists' colourmen to Queen Victoria in 1841, the first of many such appointments. The firm entered most successful exhibits at the Great Exhibitions of 1851 and 1862, at the first of which Winsor and Newton were awarded the only prize medal open to competitors for artists' colours.

Both William Winsor and Henry Newton strove to improve the quality of their materials until their respective deaths in 1865 and 1882, by which time the future of the firm and the security of their families had been guaranteed by the incorporation of the firm of Winsor and Newton Limited, with members of both families as shareholders.

Winsor and Newton's reputation spread throughout the world in the latter part of the 1800s and especially in the USA where a subsidiary company was formed in 1915.

During the past century the company has continued to expand. The present factory and administrative headquarters, which were opened in 1938, are located at Wealdstone near Harrow in Middlesex.

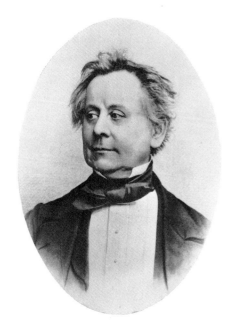

Above right
William Winsor

Right
Henry Charles Newton

A guide to the history of pigments

The story of paintmaking is an extremely long and interesting one which goes back at least 15,000 years. The earliest known paintings are the remarkable cave paintings at Lascaux in Southern France and Altamira in Northern Spain. Analyses of these paintings show that stone-age man collected and used the most suitable materials from his immediate surroundings. The pigments used were, yellow and red earths, which obtain their colour from high iron content in the earth, black from the soot of the fire, and white chalk. The binder was found to be high in amino acids and most probably was fat from the animals that were both his quarry and the subject of his paintings.

Evidence from Egyptian paintings, as early as 4,000 BC, shows a much more sophisticated approach to paintmaking. The early Egyptians used much better quality earth colours than their stone-age predecessors and added more brilliant mineral substances to the range. These were made from naturally occurring copper carbonates, green malachite and blue azurite. Malachite is found in all periods of European paintings to 1800. It was used especially for painting trees and foliage. Azurite (called bice) was also used extensively in European paintings until the end of the seventeenth century (p.26), often as a substitute for the extremely expensive ultramarine. These two pigments were obtained by crushing and washing the mineral.

Another mineral called cinnabar produced a red which was used by the Egyptians. This very heavy, hard rock, though not as bright as its manufactured successor vermilion, (both are forms of mercuric sulphide) was a useful addition to the artist's palette. The chief source of cinnabar in ancient times was Spain. When ground it yields a bright red which was the only bright red known to the ancients (Thompson 1936 p.102–3). Another mineral pigment introduced by the Egyptians was orpiment, a yellow pigment, found in Syria and which is a sulphide of arsenic. This bright yellow is mentioned by Pliny, as well as Cennini in the Renaissance when, it was used especially in manuscript illumination. Much later in history this pigment was made chemically and known as king's yellow. It was much more toxic than the naturally occurring mineral, and its use was generally avoided (Harley 1970 p.87).

The Egyptians were also advanced in the glazing of pottery and textile dyeing; the technology from these two activities gave them Alexandra blue, sometimes known as Egyptian blue frit, introduced c.2,500 BC. A glass was made by heating a mixture of sand, copper, copper ore and alkali, then the glass was ground

down to a fine powder and used as a pigment. Many of the early dyes were made from vegetable sources such as the blue woad from *Isatis tinctoria* and the red madder from *rubia tinctorum*. A dye is different from a pigment. A pigment is a coloured solid particle which can be suspended in the binder, the dye is actually completely dissolved in the binder. The Egyptians found a method of dissolving vegetable dyes in water and fixing the colour on to a transparent white powder such as chalk or gypsum to produce a pigment known as a 'lake'.

The Greeks, who inherited all of the discoveries of the Egyptians, also added to the range of pigments. They made white lead, chemically a carbonate of lead. The process by which it was made, the 'stack process' was described by Pliny, and a similar process was still in use in modern times. The Dutch developed the modern 'stack process' for making white lead which was probably the best white lead ever made for artistic painting purposes (although cremnitz white is also recommended by many artists). The white lead was made by placing strips of lead in clay pots with a separate compartment in the bottom which contained a weak solution of vinegar. The pots were placed on shelves close together in a small building, with spent tanners' bark or animal dung separating the pots. The building was then completely closed up for about three months. The combined action of the acetic acid vapours, the carbon dioxide which was emitted from the fermenting tan bark, heat, oxygen and water vapour converted the lead strips to basic carbonate of lead (which is white lead). George Dodd in his book *British Manufactures*, of 1844 described a similar method of stacking. He had seen the process in Newcastle where female labour was used in the dangerous process. Stack process white lead ceased to be made about

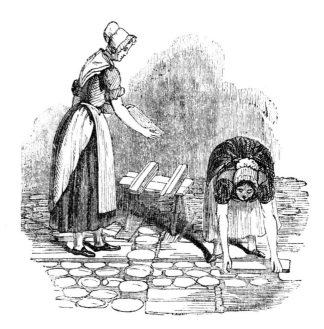

White lead stacking
(Dodd G., *British Manufactures* 1844)

twenty years ago and various more efficient processes were adopted, but none of them reproduced the particle size and shape which made the 'stack process' white lead superior (Harley 1970 p.156).

Another pigment manufactured by the Greeks, whose process has a long history is red

lead, composed of lead monoxide and lead peroxide. It is still used today, less as an artists' colour than as an oil priming pigment to protect steelwork from rusting. The method for making red lead described by Pliny is very similar to the one described by George Dodd and illustrated in *British Manufactures*, 1844.

'The man continuously stirs the molten lead. His object is to let every part of the metallic mass come up to the surface and have contact with the air. This process is continued for five to six hours by which time the lead has lost its fluidity and become a greyish yellow powder. The powder is milled, ground and washed. A yellow powder diffuses in the water and the metallic lead sinks. The yellow fluid deposits its yellow sediment, and the pure oxide of lead called massicot is converted to red lead by heating and stirring in the furnace' (Harley 1970 p.112).

The by-product of the red lead process produced by the Greeks, was massicot (lead monoxide) which did not have a very good reputation for durability. This same un-reliability also applies to another pigment used by the Greeks, verdigris, (basic copper acetate). According to Pliny it was prepared by exposing copper to the vapours of fermenting grape skins. This colour too remained on the painter's palette (p.26). It was a favourite pigment in early Italian oil painting, but in many cases it has turned brown (Thompson 1936 p.163–9). The centre of production of verdigris in the seventeenth century was Montpellier in France, where it was produced in large quantities for the decorating industry. It was cheap and this

made it a popular pigment in the seventeenth and eighteenth centuries. It was prepared by pouring sour red wine into earthenware pots to

Red lead manufacture in the nineteenth century
(Dodd G., *British Manufactures* 1844)

a depth of two or three inches. Then grape stalks, and small copper plates were placed in alternate layers on a grille above the level of the wine, space was left between the plates to allow the acid fumes to circulate. The pots were covered and left in a cellar for five or six days and then the copper plates were turned and left for a further three or four days. The plates were removed and sprinkled with wine, pressed under weights and left for some days. Finally, the green matter was scraped off the plates,

moulded into lumps and dried ready for sale (Harley 1970 p. 73–5).

After the introduction of white lead, probably the next most important pigment introduced by the Greeks was the more brilliant, artificially made vermilion, (mercuric sulphide) which replaced cinnabar. The manufacture of vermilion by the combination of mercury and sulphur was developed by alchemists but the method of manufacture was not widely known in the West until around the twelfth century. By the fifteenth century recipes for the pigment were common. It was the best bright red pigment available in the Middle Ages. Synthesis is achieved by heating a mixture of mercury and sulphur together in a flask. This vaporises and re-condenses at the top of the flask. The vermilion is taken out and ground. At first the colour is almost black. The red colour develops with grinding and the longer it is ground the finer the colour. Cennini writes that 'if you ground it every day for twenty years, the colour would still become finer and more handsome' (Thompson 1936 p.104).

Early Italian painters continued to use Greek painting methods as well as their colours. The Italians of the Middle Ages and Renaissance also made contributions to the introduction of new pigments. Naples yellow (lead antimoniate) was gathered from the volcanic slopes of Mount Vesuvius. However the Naples yellow found in paintings dating from the Middle Ages has been shown to be artificially made. This artificial pigment is still used in the ceramic industry.

Naples yellow has sometimes been confused with lead tin yellow, which was widely used between the fourteenth and the middle of the eighteenth century. This is an extremely stable pigment and it is a subject for speculation why it ceased to be used (p.24). The Italians also advanced the knowledge of lake making by developing lake pigments from dyes made from Indian lac, kermes and Brazilwood, although these pigments were not very fast to light.

They also improved the quality of the lakes made from madder root which had been originated in a cruder form by the Egyptians. They exploited the use of coloured earths obtained both in Italy and in neighbouring countries, such as the umbers, siennas and terre verte, which was widely used as a foundation for flesh tones by the fifteenth-century Italian painters. The umbers did not come into general use before the close of the fifteenth century; Vasari speaks of them as rather new colours. Previously browns must have been obtained by mixing blacks with reds and yellows (Thompson 1936 p.89). The dark umbers are obtained by roasting the raw pigment. When sienna is roasted it also undergoes considerable change of tone and hue – turning from raw sienna to a warm red brown.

The most important contribution of the Italian Rennaissance was the discovery of the method for the extraction of a brilliant blue pigment from the mineral lapis lazuli, called ultramarine. Lapis lazuli had been used earlier as a pigment, but it had been made by grinding lapis lazuli to a powder and incorporating it

into the medium. The rough stone, even of excellent quality contains about ninety per cent extraneous material such as calcite, silica and iron pyrites, and only ten per cent of the stone is the nearly pure blue pigment, which must be extracted to obtain the marvellous brilliant blue that features so prominently in Renaissance paintings (p.24).

Natural ultramarine was much prized not only for its high monetary value but also for the brilliance of its colour and its excellent durability to light. The stone is found in remote mountainous areas, and it is formed by volcanic fusion. Various qualities are found in Iran, China, Chile and Russia, but the finest quality comes from the Kokcha Valley in Afghanistan. There are various methods recorded for extracting the pigment particles from the colourless rock which always surrounds it. One of the most accurate methods was described by Cennino Cennini (Thompson 1936 p. 147). It describes a process of first grinding the stone down to a fine powder and then mixing the powder in a waxy resinous paste. The paste is then kneaded under water or lye. The blue ultramarine pigment is hydrophilic and is dispersed in the water, while the calcite and iron pyrites remain in the ball of resin. The kneading is done in several bowls of clean water and is left for about twenty minutes in each bowl. The best colour is always released first, followed by colour of greyer and less brilliant hue. Only the very finest stone with a violet hue will provide the best pigment, although stone of inferior quality can be used to make ultramarine ash.

Natural ultramarine is still manufactured by Winsor and Newton when stone of superior quality is available and the process has changed little since Cennini's time.

The colour range of the Renaissance was still in evidence in the seventeenth and eighteenth century, and some of them for example the siennas, ochres, vermilion, terre verte and lead white are still in use today. But at the beginning of the seventeenth century, the painter began to benefit from the expansion of industry and the development of modern scientific chemistry. Often industries unrelated to the colour trade produced pigment as by-products. For instance, the mining and glass industries in sixteenth century Italy produced smalt, which could be used as an alternative blue. Nitric acid used for refining silver produced blue and green verditer.

The first of the artificially prepared colours of the modern period, Prussian blue, (a ferric ferrocyanide) was discovered by chance by a colour maker named Diesbach sometime between 1704 and 1710. The German chemist Stahl wrote an account of the discovery in 1731. Dippel was an alchemist producing a medicinal animal oil. On one occasion some distilled animal oil which was being purified, was spilled over some potash, which was kept on one side as waste. Diesbach, who had run short of potash when making Florentine lake from cochineal, ferrous sulphate and alkali, asked Dippel if he could use the contaminated potash. The lake turned out to be very pale and when he tried to strengthen the lake it turned purple and then

deep blue. Initially Prussian blue was only made in Berlin but by 1730 the manufacture of the colour was widespread. Prussian blue was a useful addition to the artist's palette (p.65 and p.100), it was much cheaper than natural ultramarine but not as lightfast. It was a strong blue but one which could be discoloured by alkali, in contrast to ultramarine which can lose its colour if in contact with acids (Harley 1970 p.65).

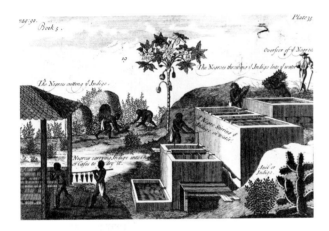

Indigo preparation
(Pomet, *Histoire generale des drogues* 1712)

The expansion of trade and the discovery of new trade routes also made pigments more available in England. Indigo which had been used from antiquity, was imported into England in large quantities in the seventeenth and eighteenth centuries for use in the dyeing industry. The plate from Pomet, *Histoire générale des drogues*, 1712, shows indigo preparation in the French West Indies during the late seventeenth century. In the background indigo plants are cut. On the right they are placed in steeping vats, and in the centre the soaking indigo is being beaten then filtered off in conical filter bags (Harley 1970 plate 4).

Two natural organic yellows are worth mentioning here as they were widely used before the inorganic, artificially prepared yellows had been developed. They both survived for several hundred years and had it not been for legislation against one of them probably they would both still be used today. Gamboge and Indian yellow originated from the Far East where they were used long before artists in the West discovered them.

Gamboge was regarded as a novelty in England when the East India Company began to import it around 1615. It is a tree resin which can be described as a complete watercolour as it is both a pigment and a gum. The gum is tapped from the tree of the Garcinia type which grows in India, Sri Lanka and Thailand, and Cambodia (hence the name). The gum is heated and run into hollow bamboo where it is allowed to cool, it is then emptied from the bamboo and sold in long round pieces like seaside rock. Gamboge is only moderately lightfast and is only suitable for use in watercolour, although it was orginally used as a pigment for spirit varnishes. It was often recommended for use in a mixture with Prussian blue to give a green as well as with burnt sienna to give an orange (Harley 1970 p.102).

Indian yellow was the other organic pigment which came from India. It was also known as

Indian puree and was made from the urine of cows that were fed on the leaves of the mango at Monghyr in Bengal. The urine was heated to precipitate a yellow substance, which was then pressed into lumps about the size of a cricket ball and dried. The colour had a remarkable resistance to fading on exposure to light. It is slightly soluble in water and was mainly used in water colours. The Indian Government eventually put a stop to the manufacture of this pigment on the grounds that it was cruel to the cattle. Gartside's *Essay on Light and Shade*, 1805 is the first printed book which contained a reference to Indian yellow. It gave a beautiful yellow, and it was listed by Fielding as one of the most useful colours for landscape painting. Since the pigment was made in India and imported into England, where it was prepared as an artists' colour, it was regarded in Europe as an English speciality (Harley 1970 p.105).

As the skills of the chemists grew new artificially made pigments began to proliferate. In 1802 Thénard discovered cobalt blue which was first made by fixing cobalt phosphate on an alumina base, although it was later made by calcining a mixture of cobalt oxide and aluminium hydrate at temperatures of $1000° - 1200°C$. Cobalt blue is very inert and lightfast and possesses a beautiful transparency especially in watercolours. It is widely used by artists.

The development of a man-made version of the traditional natural ultramarine is a fascinating story. By the beginning of the nineteenth century the cost of this pigment was so high that it was rarely used. In 1806 two French chemists, Desormes and Clément had analysed some blue material found in the slag of soda furnaces and discovered that it was chemically similar to natural ultramarine. There were no developments until 1824 when the *Société d'Encouragement pour L'Industrie Nationale* offered a prize of 6,000 francs to anyone who could discover a method of artificially making ultramarine at a cost of no more than 300 francs per kilo. Four years later the prize was awarded to J. B. Guimet of Toulouse, who developed a process just ahead of chemists in Germany, and by the early 1830s artificial ultramarine was being made commercially in England, Belgium, France, Germany and the United States. The process is essentially the calcination of soda ash, silicious materials such as china clay and silica, alumina and sulphur in an inert atmosphere followed by grinding, washing, drying and grading. The performance of artificial ultramarine is very similar to the natural ultramarine and chemically it is identical. Natural ultramarine is easily distinguished from the artificial pigment by microscopic examination. The particles are clear blue and translucent, possessing conchoidal fractures, and even the most carefully refined pigment has traces of calcite and iron pyrites present.

Another pigment that was to feature in artist colourmen's lists for about 150 years was first described by Braconnot and Fiebig in 1822. This was the highly toxic emerald green, copper aceto-arsenite. It was made by dissolving

verdigris, basic copper acetate, in warm vinegar; white arsenic dissolved in water was added to form a dirty green precipitate. Vinegar was then added to dissolve the precipitate and when the solution was boiled a bright green pigment was precipitated. Emerald green was included in artists' colourmen's lists and was used up to the 1960s. However it was only of limited use as the colour of the pigment did not resemble any of the greens in nature (p.65). It was highly toxic and turned black when heated giving off a smell like garlic. The pigment was used extensively for wallpaper colouring and proved to be an excellent rat poison. Its toxic qualities also featured prominently in several murder cases both real and fictitious (Harley 1970 p.76).

The isolation of new elements also played an important role in the development of pigments. In 1770 an orange-coloured mineral was found in the Beresof gold mine in Siberia called chrocoite. Various attempts were made to analyse it and finally Vauquelin discovered that the substance was a compound of lead with a new element which he called chrome because of the orange, green and yellow coloured precipitates that could be obtained from it. Some painters had used the natural mineral as a pigment but Vauquelin developed a process of making a yellow pigment by mixing lead acetate or lead nitrate with potassium chromate to make a variety of shades of yellow, orange and red pigments. The exact date of the commercial availability of chrome yellow is not certain because of the scarcity of the raw material. There is evidence that it was manufactured in England as early as 1816, but it was the discovery of deposits of chrome ore in the United States in 1820 that really enabled the pigment to be manufactured in quantity. Chrome yellow was to replace the old highly toxic pigment orpiment (yellow sulphide of arsenic). But chrome yellow tends to discolour on exposure to light and this has limited its use. The cost of manufacture was low and so it has survived as a pigment for artists to this day (Harley 1970 p.92).

There were three other yellow pigments developed using the element chromium. They were sold under the same name lemon yellow and were introduced around 1830. The first was barium chromate, which is the most stable and lightfast of all of the chrome yellows and is made by mixing solutions of potassium chromate and barium chloride. It is not as bright as the other chromium yellows and has a low tinting strength. Strontium chromate is the other lemon yellow and is deeper and brighter than the barium form but it is not as fast to light. It is made in a similar way to barium chromate except that the barium chloride is replaced by strontium chloride. The last of the yellow chromes to be introduced as an artists' pigment was zinc yellow which is made by adding a hot solution of potassium dichromate to a solution of zinc sulphate. Its colour is closer to strontium yellow but it lacks tinting strength and therefore it has only a limited use as an artist's colour. It is however the only chromium yellow which can be considered non-toxic.

The element chromium also gave artists two green pigments of immense value and permanence. The first pigment was the opaque form of oxide of chromium which contains no water of crystallisation. It was developed by Pannetier in Paris in 1838, and it first appears in the Winsor and Newton list of colours for artists in the early 1840s. The hydrated form of oxide of chromium, called viridian was listed in the 1849 catalogue. Both pigments are extremely durable and eventually replaced all of the copper greens such as verdigris, although emerald green was still used until the 1960s. The opaque form is high in tinting strength with excellent opacity, whilst the transparent viridian, a vivid green when used in glazes, is a very useful colour for mixing with other pigments. Viridian can be converted to the anhydrous oxide of chromium by roasting to a dull red heat (Harley 1970 p.78).

The metal cadmium was discovered by Stromeyer in 1817 but it was not until the late 1840s that cadmium yellow (cadmium sulphide) pigments were manufactured. Cadmium sulphide is found in nature as the mineral green ochite but there is no evidence that this mineral was ever used as a pigment. The manufactured cadmium yellows were prepared by precipitation from an acid solution of either cadmium chloride or cadmium sulphate with either hydrogen sulphide gas or an alkali sulphide. The colours range from lemon yellow to a deep orange, depending upon the conditions of the precipitation. It was not until 1910 that cadmium red was made commercially. It was made by precipitating cadmium sulphate with sodium sulphide and selenium. The levels of sulphur and selenium and the conditions of precipitation determine whether a yellowish red is obtained or a shade approaching a deep maroon. Cadmiums have always been rather expensive, but their excellent durability, and heat resistance have made them the most useful pigment for the artist in the yellow, orange and red part of the spectrum. Their one drawback is that their fastness to light is considerably reduced in humid atmospheres.

The zinc white oven for making Chinese white (Winsor and Newton)

Zinc was one element that was isolated by Henckel in 1721 although there are numerous references to the mining and burning of zinc ore several hundred years before this date. The use

of zinc for medicinal purposes goes back to ancient times. Towards the end of the eighteenth century zinc oxide was referred to as an artist's pigment gaining preference over white lead in water colour because it did not turn black on exposure to air and it was non-toxic. The main problem with zinc white was that it lacked opacity in both oil and water colours. It was not until Winsor and Newton developed a process of heating zinc oxide to very high temperatures to form a pigment of superior opacity, called Chinese white, that zinc oxide became widely used as a pigment for artists. Zinc white was to continue as the most important white in watercolour until the development of titanium dioxide in the 1920s (Harley 1970 p.165).

The manufacture of cobalt blue has been referred to earlier and there were two other useful artists' pigments based on cobalt developed after the blue pigment. The first of these was cobalt green which is similar to cobalt blue except that zinc oxide is used in the green to replace the aluminium oxide of the blue. Cobalt green is very inert and stable to both light and heat. It is expensive, rather pale in colour and transparent. It was developed after zinc oxide became commercially available and was first introduced as an artists' pigment in 1835 and is still widely used. Cerulean blue (cobalt stannate) is made by precipitating cobaltous chloride with potassium stannate, mixing with silica and calcium sulphate and then calcining. It has only a limited tinting strength but is very stable to heat and light and was introduced in 1860 under the name 'Coeruleum' by G. Rowney and Co. Winsor and Newton developed another cobalt salt, this time to produce a yellow pigment called aureolin, in 1889. Chemically it is potassium cobaltinitrite and is made by precipitating a cobalt salt in acid solution with a solution of potassium nitrite. It is an expensive pigment to produce and has excellent lightfastness but it can be decomposed by heat, alkalis and acids.

The distillation of coal tar, to isolate chemicals for a wide range of uses, made a further contribution to the development of pigments. In 1856 a discovery was made by Sir William Perkin that was to start a whole new industry (the coal tar dye industry) which would eventually supply a high proportion of the world's pigments. Only the very best were to remain for long in the lists of the artists' colourmen. The discovery was that of mauve, an artificial dye-stuff. This started the production of thousands of different types of complex organic pigments. Initially these dyes were made for the textile industry, although some artists' colourmen added the colours derived from them to their lists rather indiscriminately without realising that many were not fast to light. Chemicals such as nitrobenzene, toluenesulphonic acid and nitro naphthalene (called primaries) are distilled from the oil or coal tar. Then further chemicals called intermediates are made from the primaries, (involving one or more chemical reactions). An example of an intermediate is aniline which comes from nitrobenzene aniline.

Development of colour ranges

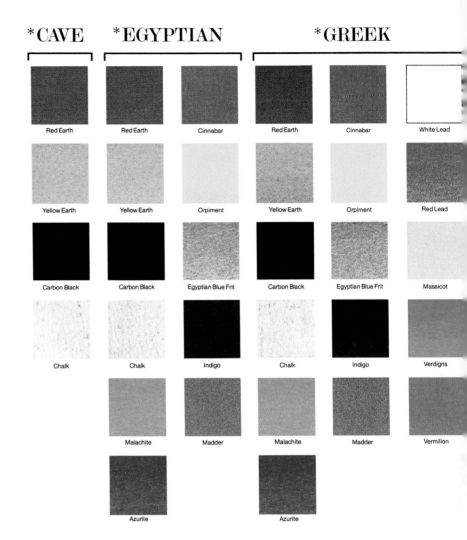

*CAVE

Red Earth	
Yellow Earth	
Carbon Black	
Chalk	

*EGYPTIAN

Red Earth	Cinnabar
Yellow Earth	Orpiment
Carbon Black	Egyptian Blue Frit
Chalk	Indigo
Malachite	Madder
Azurite	

*GREEK

Red Earth	Cinnabar	White Lead
Yellow Earth	Orpiment	Red Lead
Carbon Black	Egyptian Blue Frit	Massicot
Chalk	Indigo	Verdigris
Malachite	Madder	Vermilion
Azurite		

* complete ranges

** New colours that became available during these centuries.
Some of the traditional pigments continue to be used.

*ITALIAN **18th & 19th CENTURY **20th CENTURY

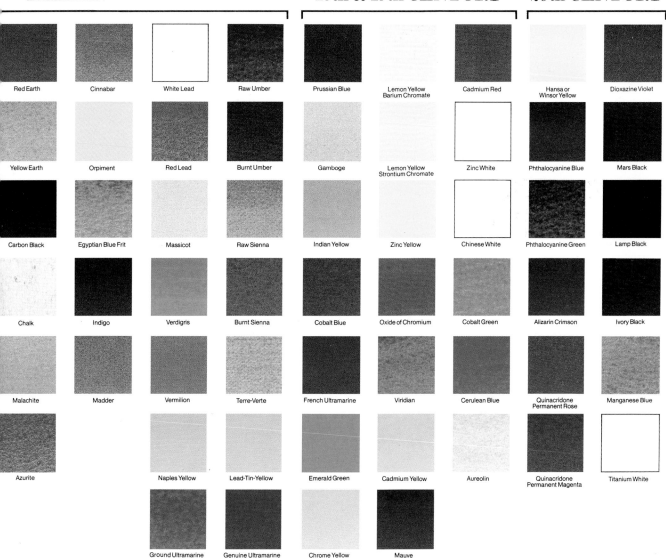

Red Earth	Cinnabar	White Lead	Raw Umber	Prussian Blue	Lemon Yellow Barium Chromate	Cadmium Red	Hansa or Winsor Yellow	Dioxazine Violet
Yellow Earth	Orpiment	Red Lead	Burnt Umber	Gamboge	Lemon Yellow Strontium Chromate	Zinc White	Phthalocyanine Blue	Mars Black
Carbon Black	Egyptian Blue Frit	Massicot	Raw Sienna	Indian Yellow	Zinc Yellow	Chinese White	Phthalocyanine Green	Lamp Black
Chalk	Indigo	Verdigris	Burnt Sienna	Cobalt Blue	Oxide of Chromium	Cobalt Green	Alizarin Crimson	Ivory Black
Malachite	Madder	Vermilion	Terre-Verte	French Ultramarine	Viridian	Cerulean Blue	Quinacridone Permanent Rose	Manganese Blue
Azurite		Naples Yellow	Lead-Tin-Yellow	Emerald Green	Cadmium Yellow	Aureolin	Quinacridone Permanent Magenta	Titanium White
		Ground Ultramarine	Genuine Ultramarine	Chrome Yellow	Mauve			

The intermediates are converted directly into pigments or sometimes to dyestuffs, which can be made into pigments by making a lake which is a method of fixing the dye onto an inert white extender pigment such as aluminium hydroxide or *blanc fixe*, the same principle as that used by the Egyptians when they first made madder.

One of the most permanent of the organic pigments made from the modern synthetic yellow dyes was the group of pigments first brought out by the German Hoechst company which they called the Hansa yellows. These were later made by all the other colour manufacturers. They are of the diazo group, and are made by coupling diazotised amines containing nitroso and or halide groups with acetoacetanilide or one of its derivatives. Many artists' colourmen had to find alternative names for these pigments. The name Hansa was registered by the Hoechst company. Since the chemical name is complex Winsor and Newton call the colour Winsor yellow. To enable the artist to know the composition of these complex pigments, Winsor and Newton publish a description of their pigments together with the colour index name and number, which refer to *The Colour Index* published by the British Society of Dyers and Colourists. This is the only reference book which attempts to describe chemically all the pigments and dyestuffs.

One of the most valuable contributions to the artist's palette came by chance in the factory of Scottish Dyes Ltd in 1928 when an impurity was noticed in a batch of phthalimide. It was found to be iron phthalocyanine. Experiments were carried out replacing the iron with other metals and during the most promising, a deep blue pigment of great colour strength was precipitated. The pigment was developed by I.C.I. who took over Scottish Dyes and, in 1936 they launched the copper phthalocyanine blue as Monastral blue. Soon afterwards a halogen was attached to the molecule which gave a very strong green pigment which they called Monastral green. Winsor and Newton launched the two pigments in both oil and watercolours under the name Winsor blue and Winsor green. Both pigments are very inert, have excellent lightfastness and are very strong tinctorially. They are three times as strong as Prussian blue, which may in the future lose ground to phthalocyanine blue.

Another important organic pigment was alizarin crimson. This was introduced in 1868 following work by two German chemists Graibe and Lieberman who were the first chemists to synthesize a natural dyestuff. Chemically alizarin crimson is similar to the ancient lake made from rose madder. The synthetic lake is stronger tinctorially but is not as fast to light. It is however far less expensive to produce. Chemically both alizarin crimson and rose madder are described as 1:2 dihydroxyanthraquinone.

Since the 1950s several expensive organic pigments have been developed which have been added to the artists' colourmen's lists. Two quinacridone pigments, permanent rose and permanent magenta, and dioxazine violet or Winsor violet have a lightfastness equal to the

phthalocyanine, but not the same tinting strength.

There have also been a number of additions of inorganic pigments from the middle of the nineteenth century. A whole range of synthetic iron oxides in the brown to purple brown range have been prepared and these duplicate most of the naturally occurring brown earth colours. They are just as inert and just as lightfast and have about three times the tinting strength of the natural earths. The natural earths of good quality however still have an advantage over the synthetics as undertones when glazing colours are required. The synthetic iron oxides are often called Mars colours, and are more vibrant. An iron oxide black called Mars black is a useful addition to the two traditional blacks – lamp black, made by burning various resins, oils or waxes and collecting the soot, and bone black traditionally known to artist's colourmen as ivory black, which is made by burning degreased animal bones. Lamp black has a bluish undertone and ivory black a browny undertone. The Mars blacks are weaker in tinting strength but tend to be more inert than the carbon blacks which makes them useful as black pigments in the highly alkaline modern acrylic and poly vinyl acetate emulsions.

Ground slate is used to make some grey pigments such as Payne's grey and Davy's grey. Again these pigments are extremely lightfast and inert but they tend to be rather coarse.

Two inorganic metallic salt pigments were added this century. In 1935 manganese blue was introduced. This is a greenish blue pigment which is barium manganate fixed onto a barium sulphate base. It is made by calcining mixtures of sodium sulphate, potassium permanganate and barium nitrate at about 800°C in the presence of air. It is extremely inert and lightfast but weak in tinctorial strength.

Perhaps the most important pigment of the twentieth century in terms of consumption is titanium white (titanium dioxide). The element was identified and named by a German chemist Klaproth in 1795, but it was not until 1920 that an economic method of manufacture which is basically concerned with the purification of ilmenite, a naturally occurring titanium dioxide which contains a percentage of iron. There are two types of titanium dioxide, anatase and rutile, as well as two methods of manufacture, the original sulphate process and the more recent chloride process. The quality of titanium dioxide has continued to improve and its high tinting strength, excellent durability and inert nature has already made it the largest selling white in most artists' colour ranges.

Warning: many of the pigments described are highly toxic and it is not advisable to attempt to make them, or even use them without first consulting the manufacturers' literature.

Innocenzo da Imola *c.*1494–1547
Mary Magdalene Reading
Oil(?) on panel, 65 × 48 (25½ × 18⅞)
Courtauld Institute Galleries

THE PIGMENTS

YELLOWS
The bright yellow in the sleeve is lead tin yellow. In the sleeve it is mixed with lead white and, unusually in the deepest shadow by the elbow, black. Lead tin yellow is also found in the corners of the eyes and the stamens of the iris. Yellow ochres are used in mixtures in the flesh, hair and landscape rocks.

GREENS
The green most widely used in the upper paint layers is copper resinate (a compound of verdigris with venice turpentine). In the tunic the mixed tones and shadows are achieved by glazing copper resinate over a layer of verdigris mixed with lead white. In the lights it is applied over a layer of lead white.

The foliage of the tree is discoloured copper resinate painted in a single layer. The leaves of the Iris plant are mainly malachite and lead white and there are traces of an eroded copper resinate glaze.

REDS
The red drapery has a complicated paint structure. It is mainly vermilion mixed with lead white glazed with organic red lakes, probably derived from madder root or kermes/cochineal insects. Unusually, in the deepest shadow a mixed red layer containing black has been applied over the vermilion.

Vermilion mixed with ochres and lead white is used for the flesh tones. Traces of red lake are also found in the flesh, the corners of the eyes and mixed with black and lead white in the shadow of the mouth.

PURPLES
A suitable purple pigment did not exist for panel painting. The colour is achieved by glazing with a red lake over a layer of vermilion, blue and lead white. On the collar and cuff the blue is ultramarine (lapis lazuli) and on the cloth of honour it is azurite.

BLUES
In all the top layers of the paint structure the blue is ultramarine (lapis lazuli). In the drapery the mix tones and shadows are achieved by glazing ultramarine over a mixture of azurite and lead white; the lights are a mixture of ultramarine and lead white.

Ultramarine is used in all the sky painting. Traces are found in the whites of the eye and more in the shadows of the flesh paint.

WHITE
The only white used is lead white. The ground is calcium sulphate and in some areas a thin layer of lead white has been applied over the ground.

BLACKS
A fine-particled carbon black is used. In all the grey areas, for example, the pearls and foreground sill, it is mixed with lead white.

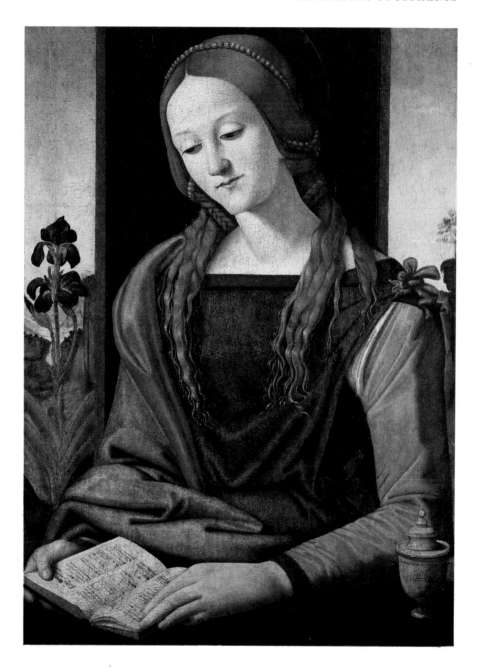

Innocenzo da Imola
Mary Magdalene Reading

Master of the Groote Adoration
active 1520
Scene from the Life of a Bishop
(left panel of a pair)

Oil on panel, 79 × 57.2 (31⅛ × 22½)
Courtauld Institute Galleries

THE PIGMENTS

YELLOWS

The bright yellow used in the garments, the brocade and jewellery highlights and the devils in the sky on the left is lead tin yellow.

Yellow ochre has been used in the foreground area of the landscape.

GREENS

The green in the Bishop's robe is composed of verdigris, as is the green of the bushes and shrubs in the middle distance. The highlights of the foliage, however, are achieved by the application of lead tin yellow over a layer of azurite mixed with lead white. This use of blue and yellow to create green can perhaps be attributed to the difficulty of manufacturing stable green pigments before the discovery of modern synthetically produced greens.

REDS

The red draperies are painted in vermilion, mixed with lead white to form the highlights and glazed with cochineal lake in the shadows. The pink draperies are composed simply of lake and lead white.

The flesh tones of the figures consist of lead white, mixed with a small amount of vermilion and yellow ochre. Burnt umber has been used as a glaze to indicate the shadowed areas.

BLUES

Blue is the dominant colour in this painting. The pigment azurite has been used in the drapery and hat of the bishop and two other figures, in the landscape background and in the sky. The azurite has been mixed with varying quantities of lead white to create the highlights and mid-tones of the draperies and in the background, but it has been used alone to achieve depth in the shadow areas. Azurite mixed with lead white is also present in a continuous layer beneath the brown building on the right of the picture, and in some areas of the land in the foreground.

Traces of blue can also be found in the whites of the eyes of the figures. This is best observed in the right eye of the saint.

BROWNS

Earths, umbers and ochres have been used in the background of the painting. Burnt umber was identified in the building on the right.

BLACKS

The black pigment used in the saint's drapery, in the ship, and in other areas of the picture is intense, and composed of fine particles. It is most probably lamp black.

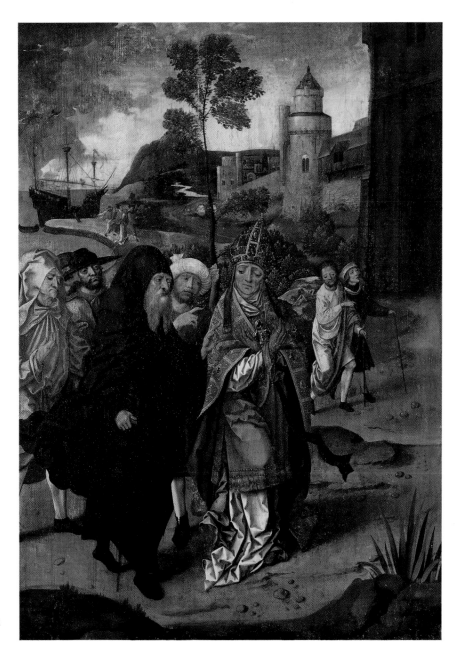

Master of the Groote Adoration
Scene from the Life of a Bishop

Madder lake

The Notebooks of George Field (Photographs exhibited) Courtauld Institute of Art

George Field, who supplied Constable and Holman Hunt with some of their pigments, was the outstanding colourmaker of the nineteenth century. He specialised in the manufacture of madder lake pigments, and produced a range of pigments from the madder root which varied from rose, to brown and purple. Ten volumes of notebooks record the experiments he carried out to improve the quality of lakes; his designs for machinery, and factory layout to improve the speed and efficiency of production.

Madder (*rubia tinctorum*) grew wild both in Europe and the Near East. The dye extracted from its roots was used in textile dyeing by the Egyptians. In the seventeenth century the Dutch became the most advanced growers in Europe; and in the 1750s, Britain was importing all of its madder from Holland at a cost of £300,000 annually, for use in the dyeing and textile printing industries.

In 1755, the Society for the Encouragement of the Arts offered a premium to encourage madder cultivation in England. At first, production was stimulated but later declined. However, the attempt at home production caused the Dutch to lower their prices.

Madder is barely documented as an artist colour until the early nineteenth century, although Constant de Massoul says that it is the most permanent lake pigment. Madder root is not easily soluble in water, So George Field developed a press for extracting the dye. The madder was held in a bag under pressure, while water ran through the bag, carrying the dye to a vat below, where it was filtered and the precipitate was washed many times. The filtration goes on more slowly as the sediment falls and the fluid becomes thick (Harley 1970 p.128).

In his 1804 notebook, George Field pressed samples of the madder plant which he had found growing wild in England. He then painted a picture of the Dutch madder from which the best pigment was obtained, and decorated it with a pink bow painted with the colour he had produced from the plant.

A lake pigment is one which is made by precipitating a dye on a base which is usually insoluble, inorganic and inert, such as aluminium hydrate or calcium sulphate.

Field in vol. iii of his notebook of 1807, experiment 107, describes the manufacture of a madder lake, having obtained the dye from the root:

'I now took the 52 lb of madder from which I had obtained the foregoing colour, having first washed it with much water I turned it from the filter bags into 4 tubs after the water had drained from it.
I now took 18 lb of powered alum, dissolved it in about two tubs full of hot water – precipitated it with near 10 lbs of salt of tartar dissolved in hot

The Madder plant from George Field's notebook 1804

water – filtered in three cotton filters – edulcorated the precipitate during the day with about 20 galls of water, next day re-dissolved the precipitated alumina in 9 lb of Muriatic acid – diluted the whole until it measured 54 quarts.

I then added this fluid to the above 52 lb of madder in the tub in the proportion of 1 quart to a pound of madder, stirring them at intervals during two days.

– The above madder some of which had been in the bags six weeks, tho' washed daily by pouring water thro' it in the bags and stirring, smelt very strong and the bag which had been longest wet had bred a number of small worms on the outside (yet this madder does not seem to yield less beautiful tincture than the latest, and if any difference, is

rather deeper coloured). The wet madder appeared at top of the bags of a deep chocolate colour verging on black but near the bottom of all the bags it appeared a much lighter brown or nearly of it's original colour; I therefore suspect where it appeared of this latter colour, the water and the stirring had not reached it.

The madder and mordant having macerated two days as above, I strained the red tincture therefrom thro' the flannel bags and muslin sieve into a clear tub – let it rest, elutriated it, precipitated it with a clear solution of alkali not in excess – edulcorated the precipitate in cotton filtered during a day – pressed off the moisture and dried it the sun where it yielded about 2 lb 9 oz of pigment. [Field notebooks vol. III 1807].

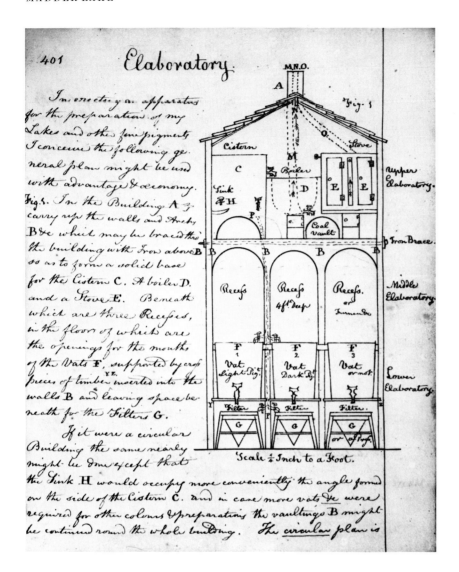

The lake laboratory from
George Field's notebook 1809

The laboratory for the preparation of lakes drawn by Field in the 1809 notebook is very similar to the area at Winsor and Newton where the genuine pigment is still made. It is devised on three storeys with the boiler and cistern on the top, the steeping vats on the middle and the filters on the ground floor, so that the water drains easily away.

The manufacture of artists' colour

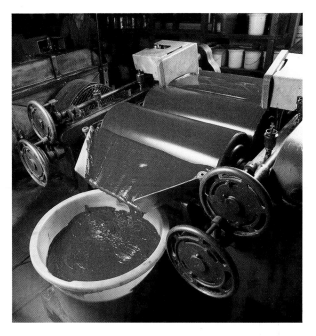

A triple-roll mill for grinding paint
(Winsor and Newton)

Two basic operations are carried out in the manufacture of paint. First the pigment (usually supplied in lumps) must be separated into individual particles. Then the pigment is dispersed in the liquid portion of the paint, the medium. Wetting agents are added, as well as volatile materials such as solvents (in oil paint) and water (for watercolour). These evaporate after the paint has been applied to a painting.

When artists prepared their own paint, the dry pigment was ground on a slab using a muller and water to separate and reduce the particle size of the pigment, then the water was evaporated off. To obtain paint, the pigment was then mixed, using a spatula or palette knife, with sufficient medium to make an easily workable paint. In the modern colourman's factory a variety of mixers are used to accommodate the mixing requirements of different pigments. The larger mixing machines have electric motors (about seventy-five horsepower) which enable the power to be cycled through a hydraulic system, to mix the colours at varying speeds and power to suit the particular requirements of the pigments. Other mixers resemble large versions of those used in the kitchen. There are also mixing machines which can work under vacuum keeping air out of the mixture.

Most of the dispersion process is carried out on triple roll mills. These have three granite rolls which run in opposite directions to each other and at different speeds. Granite rolls are always used for watercolours but some oil colours are dispersed on similar triple roll mills which have water-cooled, chilled iron rolls. Most colours pass through the mills several times before they achieve the correct colour, consistency and pigment particle size. Some colours like genuine ultramarine ash are still

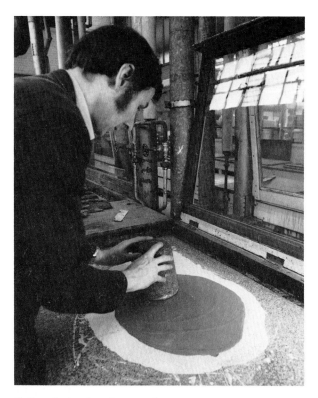

Colour being hand ground
(Winsor and Newton)

hand ground on a granite slab using a muller.

Every formulation in a range of colours is different because each pigment type requires a specific medium, wetting agent, method of mixing and milling. Pigments vary considerably in particle size and shape and this largely determines the amount of medium which will be required, as well as the difficulty in thoroughly dispersing them in the medium.

It is the different media which really give artists' paints their different characteristics.

Watercolours are made using a variety of gums. Gum arabic which derives from the acacia tree, is water soluble. It was used by the Egyptians and is still the most important gum. The gum is dissolved in hot water using an electric stirrer in a copper mixing container and it is then filtered to remove dirt and other undesirable matter. Because most pigments are not easily mixed into aqueous solutions a wide variety of wetting agents, such as clarified ox-gall and special types of detergents, are used to help the dispersion process. Other ingredients found in watercolours are sugar and glycerine which prevent the colours drying out completely, as well as preservatives which prevent mould from forming on the colour cakes. Most colourmen are reticent about the precise ingredients of these mixtures, which vary according to the composition of the pigment but the colourman, Ackermann, in 1801 published the recipes for the compositions used by him (p.41). The medium is mixed in very precise quantities, consulting the process books which are kept by colourmen to record the various formulas as well as the results of tests carried out by them, and filtered off through muslin before it is mixed with the pigment.

The watercolours are then blended with the medium into a wide variety of consistencies, some are very liquid, some very stiff. The colours that are ground in a very liquid state have the excess liquid dried out before the colour can be filled into tubes. Pan colours are almost completely dried out on granite slabs in the drying room. The slabs are heated to a wide

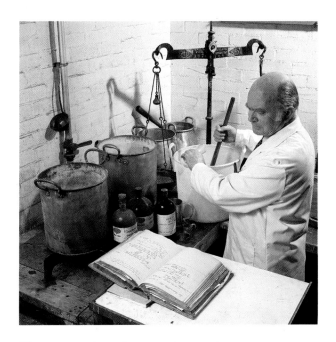

The preparation of watercolour media at Winsor and Newton

variety of temperatures, these depend upon the sensitivity of a particular colour to heat. When the pan colour reaches the consistency of a fairly hard slab of toffee it is extruded into strips of colour and cut up into neat little colour cakes.

A more opaque type of watercolour, called gouache, is produced by the addition of white pigment to the watercolour, such as zinc or titanium dioxide.

Oil colours are prepared by mixing the pigment with oil, in an exact proportion by weight. The oil used is usually linseed oil although safflower oil is used when its greater

resistance to yellowing is an advantage (for some whites and pale colours). The manufacture of oil colour follows a similar pattern to that of watercolour. They are first mixed in mechanical mixers and then ground on triple roll mills. Unlike watercolour they are milled to the consistency needed for the tube colour. After milling the paint is kept to mature. Some colours are improved by being allowed to mature in large jars before filling into tubes.

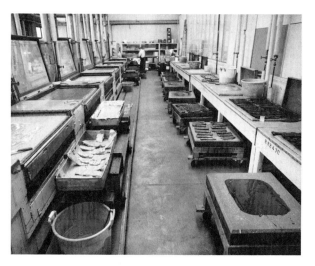

The drying room at Winsor and Newton

The twentieth century has seen advances in the range of painting media. In the 1950s and 1960s ranges of acrylic colours were developed, based on methyl methacrylate emulsions and poly-vinyl acetate emulsions. These synthetically made media were produced originally for the decorative paint industry. They are water

soluble when wet, quick drying and waterproof when dry. They are pigmented with both traditional and modern pigments. Acrylic colours are prepared following a slightly different process. The pigment is first mixed and ground in the various wet parts of the formulation, which does not contain the acrylic medium. The medium is added in a subsequent mixing operation under vacuum to ensure that no air is trapped in the colour.

In the late seventies Winsor and Newton introduced colours based on alkyd resins. Alkyd, like the polymer emulsions were made originally for decorative or industrial use. Alkyd resins are made by chemically combining a few of the ingredients which are found in natural drying oils and resins. They provide a modern alternative to conventional oil paint. They are faster drying, more durable and have an improved resistance to yellowing. The process for manufacturing is similar to that described for making oil colours.

The trade of the artists' colourman

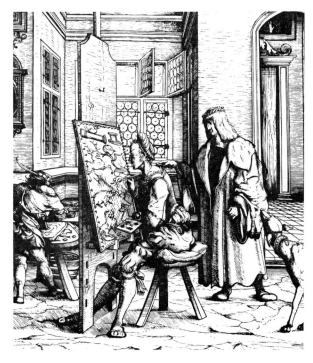

The Emperor Maximilian in the Artist's Workshop (from *Weisskunig* 1514–16)

During the Middle Ages and the Renaissance, the paint used by artists was prepared in the studio. The painter purchased pigment from apothecaries' shops, and it was then prepared for use by apprentices, who also prepared panels and grounds for the master painter and carried out the early, elementary stages of a painting.

To obtain a smooth spreading paint, the pigment had to be hand ground into particles of fairly uniform size. Most pigments were ground as smoothly as possible to improve their colour, and to make a better flowing paint. The pigment was then mixed with sufficient medium to make an easily workable paint. The recipes or instructions used by painters in the Renaissance were handed down from master to pupil. They survive both as manuscripts and printed books. Rosamond Harley gives an excellent survey of these early manuscripts and books (Harley, 1970 p.1ff). Cennino Cennini's book, which was translated by Daniel Thompson in 1933, is a classic. It gives detailed accounts of the methods used for refining and purifying pigments. It draws attention to the appropriateness of a pigment for use, especially from the point of view of its permanence, as well as giving detailed instructions for the preparation of the media, which may vary according to the properties of the pigment.

During the Renaissance, painting became increasingly secularised. At the same time literary works, like Alberti's *On Painting*, which concentrated on the more theoretical aspects of painting and drawing, emphasised the need for the painter to acquire a much wider range of skills than the purely manual, in order to produce satisfactory works of art. For instance a thorough knowledge of geometry was needed

to render perspective correctly. The response to Alberti's challenge led to a change in status from the craftsman, who was well versed in manual skills, to the professional artist who was well grounded in the use of materials and in full possession of a broad education. Painting also became a necessary part of an aristocratic education.

By the beginning of the seventeenth century, painting was increasingly regarded as what we would now call an art rather than a craft, and this development was paralleled by an increasing number of amateur painters. The professional painter continued to gain his knowledge of materials and techniques in the studio, while the amateur was instructed by tutors and books.

Henry Peacham (1576–1644), a well-known writer on education, who had been a tutor to the sons of Thomas Howard, Earl of Arundel recommended that young noblemen should practice topographical painting:

'for practice of the hand doth speedily instruct the minde, and strongly confirme the memory beyond anything else, nor thinke it any disgrace unto you, since in other countries it is the practice of the Princes . . .'

In his book *The Compleat Gentleman* 1622, he makes a comparison between painting in oil and watercolour, giving the reasons why water-colour is more suitable for the amateur:

'Painting in Oyle is done, I confesse, with greater judgement, and is generally of more esteeme than working in water colours; but then it is more Mechanique and will robbe you of over much time from your more excellent studies, it being sometime a fortnight or moneth ere you can finish an ordinary peece . . . Beside, oyle nor oyle-colours, if they drop upon apparrell, will not out, when water colour will with the least washing . . .'

By the middle of the seventeenth century, an area of trade had come into being, the artists' colourmen, who supplied prepared pigments, made brushes, prepared canvases and any other items required by the artist. The emergence of the trade may well have been stimulated by the increasing amateur interest in painting. Many professionals continued to assess and prepare their own pigments, possibly through fear of the adulteration of pigments by apothecaries or colourmen. Expensive pigments like natural ultramarine or vermilion had often been adulterated with cheap additives by un-scrupulous suppliers.

From early eighteenth-century trade cards, it is clear that most colourmen were supplying paint manufactured in bulk for industrial purposes, for example, house painting or theatrical scene painting, as well as in small quantities for sale to artists. To manufacture paint in large quantities, Alexander Emerton, who had been in business since at least 1725, and who sold 'all sorts of colours, ready prepared', used horse mills to grind the colour. Elizabeth Emerton announcing the con-tinuation of her husband's firm in *c.*1741 added that 'as her colours are ground in Horse-Mills, of which there is not the like in England, they are prepared in much greater perfection, and sold considerably Cheaper than by any of the

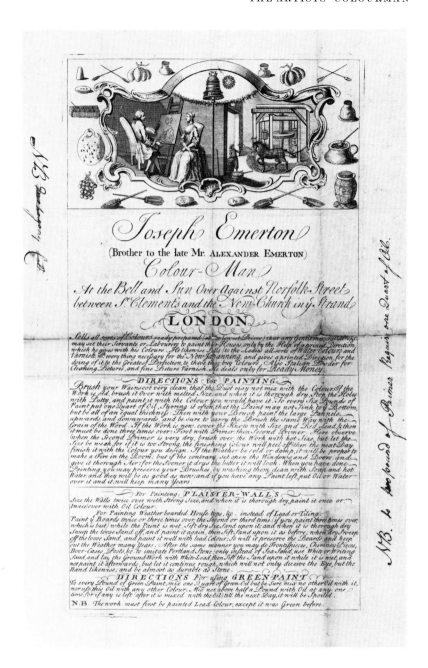

The trade card of Joseph Emerton
(Heal Collection, British Museum)

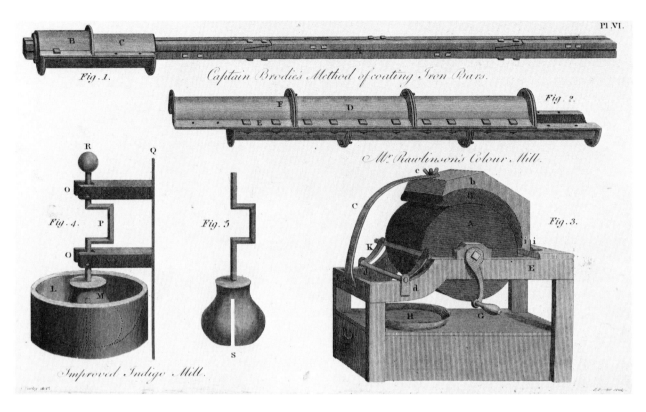

Rawlinson's hand operated single-roll grinding mill 1804

Trade, that have not such conveniences, but grind their colours in Hand-Mills, or upon a stone with great Expense and Labour.' The horse-mill can be seen at the top of Joseph Emerton's trade card, the printed directions which he gave with his colours. The directions here describe the correct way to paint wainscoting as well as plaster walls. He stated at the top, 'He likewise sells to the Ladies all sorts of Water Colours and varnish with everything necessary for New Jappaning; and gives Direction for the doing of it to the Greatest Perfection, to those that buy Colours.' (Bristow 1977 p.247).

The basic machines used by colourmen were grinding mills, which were of course used in many other trades. In the nineteenth century, some machinery was developed specifically for colourmen. Rawlinson's hand-operated, single roll grinding mill was recommended by the

Royal Society of Arts in 1804: A is the marble roll and B the concave muller covering one third of the roll; C is a piece of iron to keep the muller steady; D is the spring which took off the colour when the action of the roll was reversed and the paint was collected in the tray; H the muller was designed so that the mill could be cleaned with curriers shavings which were kept in a drawer below the mill (Harley 1970 pl.8). Middleton, probably the best known colourman of the day, said that he intended to put it into immediate use as the demand for the colours it was calculated to grind is very considerable (Harley 1970 p.38).

Another apparatus designed in France in 1796, protected the colourman who was hand grinding toxic pigments. The grinding slab B stands on supports D which are surrounded by box table A and C; a small gap between A and B allows fresh air drawn up by a charcoal fire at G to pass into the pipe F, so carrying away the pigment particles and dangerous fumes. The workman could watch his work through the transparent glass shield F (Harley 1970 pl.7).

Watercolours first sold by colourmen in shells were later supplied in oblong cakes. The pigment was mixed in a medium of water and gum arabic and allowed to dry. These colour cakes were hard and irregularly shaped and they had to be grated before the colour could be used. The firm Middleton's who specialised in supplying paint to theatrical scene painters were the first to develop this kind of colour cake (p. 57). One of the Middleton's employees, William Reeves accidentally discovered that

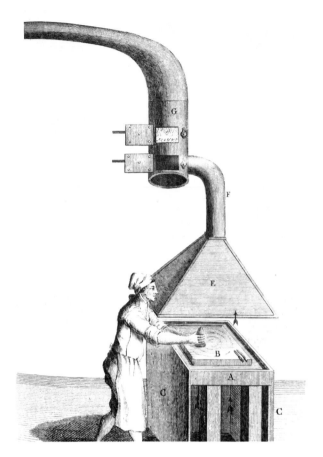

Toxic grinding apparatus 1796

the addition of honey to the medium of gum arabic prevented the colour cakes from drying out completely. They would resist cracking in storage, and they could be moulded into neat watercolour cakes which easily fitted into boxes. His brother, a member of the Gold and Silversmiths' Company, made some moulds and

a small business was started in Little Britain, near St Pauls in 1776. This was the beginning of Reeves and Son, who are still in business today. The watercolour cake was further improved by Winsor and Newton, who, exploiting the moisture retaining properties of glycerine, added it to the gum arabic medium and made moist watercolour. This had the advantage over the others in that the colour could be worked up directly with water without needing to be grated first.

By the nineteenth century, many professional artists as well as amateurs were content to leave the arduous work and technical skills of making paint to artists' colourmen. From the beginning of the nineteenth century, colourmen were producing books. The first book by a manufacturing colourman is by Constant de Massoul, *A Treatise on the Art of Painting and the Composition of Colours*. Published in 1797 it gives a survey of techniques, as well as providing a list of colours available from him. Short books were published by the colourmen Ackermann and Winsor and Newton supplying details of their products. This literature was intended to help the artist select materials from a wide range. They also encouraged trade. The export of 'colours for artists' from Britain to America and Europe greatly increased in the late eighteenth and early nineteenth centuries.

By the 1830s there were several reputable artists' colourmen in London. The Reeves brothers, who had developed the colour cake, and established an important export market, supplying through the East India Company,

LIST OF
ACKERMANN'S SUPERFINE WATER
COLOURS.

Prepared and sold at his REPOSITORY of ARTS 101, Strand and may be had of all Print and Booksellers in Great Britain.

Ackermann's Yellow	Crocus Martis	Olive Green
Ackermann's White	Dragon's Blood	Patent Yellow
Antwerp Blue	Dutch Pink	Peach Black
Azure Blue	Enamel Blue	Prussian Blue
Azure Green	Egyptian Brown	Prussian Green
Bister	French Green	Purple
Blue Black	Gall Stone	Red Ochre
Blue Verditer	Gamboge	Red Orpiment
Bone Black	Green Verditer	Raw Sienna
Brown Lake	Green Lake	Rose Pink
Brown Ochre	Green Earth	Royal Smalt
Brown Pink	Indigo	Sanders Blue
Brown Red	Indian Red	Sanders Green
Burnt Carmine	Iris Green	Sap Green
Burnt Sienna	Ivory Black	Saturnine Red
Burnt Umber	King's Yellow	Vandyke Brown
Carmine	Lake	Vermillion
Carmined Lake	Lamp Black	Violet Blue
Calcined Vitrol	Light Lake	White Lead
Carnation Red	Light White	Yellow Ochre
Carbonic Black	Mars Yellow	Yellow Lake
Chinese Vermillion	Massicot	Yellow Orpiment
Cologn Earth	Mineral Green	

Above and opposite Ackermann's composition of the media for watercolour *A treatise on superfine watercolours* 1801 (University of London Library)

colour boxes and materials for the use of officers on survey duties in India, were established at 150 Cheapside. Rowney whose business in the eighteenth century had primarily been *pencil* making, was producing colours and selling them in Percy Street. In the eighteenth century

Colours to be prepared with the First Composition.

Ackermann's Yellow	Enamel Blue	Olive Green
Antwerp Blue	Egyptian Brown	Pink
Azure Blue	French Green	Purple
Azure Green	Green Earth	Patent Yellow
Brown Red	Indian Red	Sanders Blue
Burnt Umber	Iris Green	Sanders Green
Blue Earth	Lake	Sienna Earth
Brown Pink	Mars Red	Vandyke Brown
Black	Mars Yellow	Violet Blue
Cologn Earth	Mineral Green	Vermillion
Dutch Pink	Orpiment	Umber
Dragon's Blood	Ochre	

To be prepared with the Second Composition.

Bister, Prussian Blue, and Burnt Carmine.

Colours for the Third Composition.

All the different Whites, and it is very necessary to select the pure sorts and to grind them extremely fine.

Colours for the Fourth Composition.

Carmine, Precipitate of Gold, Ultramarine, Smalt.

Colours in the Preparation of which no Iron Knife ought to be used.

The Whites, Smalt, Orpiment, the Yellows (the Ochres excepted), Orange Lead, Ultramarine, Carmine, Lake, Gall-Stone.

PREPARATION OF COLOURS FOR PAINTING IN MINIATURE, LANDSCAPES, FLOWERS, SHELLS, ETC.

The colours must be mixed upon the marble plate with the following different liquids, viz.

FIRST COMPOSITION – To two quarts of distilled water, add twelve ounces of Gum Senegal, and five ounces of Sugar Candy; let the whole be dissolved in a vapour bath, and filter it afterwards through blotting paper.

SECOND COMPOSITION – To a vessel, containing two quarts, pour in one pound of distilled Vinegar, fourteen ounces of Gum Senegal, six ounces of Sugar Candy, two ounces of white Honey, and fill it up with distilled Water; let it dissolve and filter it.

THIRD COMPOSITION – Take two quarts of distilled Water, five ounces of Gum Arabic, and two ounces of Sugar Candy, dissolve and filter it.

FOURTH COMPOSITION – Dissolve three ounces of Gum Senegal and one ounce of Sugar Candy in two quarts of distilled Water, and filter it.

'pencil' meant what we would call a fine brush. Another company Roberson was also gaining a reputation for their canvases and easels.

In 1801 Robert Ackermann, print seller and colourman of 101 Strand was offering sixty-eight prepared watercolours for sale. He also sold raw materials for artists who wanted to prepare their own colours as well as the compositions of the various media for water-colours, but he advised 'I should lead the reader into error were I to advise him to prepare his own colours. The time, the trouble, the expense of attending their preparation will never compensate the small saving gained by it.' Ackermann is the only colourman who quotes the recipes for the media. The little pamphlet now exists only as a photo copy in the University of London Library, it is therefore

worth publishing the compositions here.

Most of the colourmen were producing colour from traditional pigments, manufactured by traditional methods. They augmented the range with the addition of a few colours of dubious permanence such as carmine, made from the cochineal beetle, or bistre which was made by charring beechwood.

The advances in the scientific chemical industries at the close of the eighteenth century and throughout the nineteenth century produced an enormous expansion in the range of pigments. Some of these new pigments made valuable additions to the artists' colour range by providing cheaper alternatives for expensive traditional pigments, for example, artificial ultramarine. These new pigments could also provide a more permanent or durable colour than the available traditional colours (cadmium yellow replaced orpiment).

Unfamiliarity with the new pigments, as well as a loss of technical expertise on the part of artists, many of whom were no longer trained in the workshops, gave rise to disputes over the quality of the products supplied by colourmen. These complaints were usually concerned with the lightfastness of the colours. Given the chemical complexity of these new pigments, colourmen without a training in science would have had great difficulty in assessing the new pigments.

In the eighteenth century, few books were written which were concerned with the technology of colour. In the early nineteenth century, when the range of pigment was wider than ever before, it was necessary for painters to take even more care over the selection of their colours. Information on paint technology began to increase.

George Field in his book *Chromatography* of 1835, the standard work on colour for artists, did a great deal to supply the painter with the necessary information on colours. However, he believed that the ultimate responsibility for the choice and use of artists materials lay entirely with the artist.

The 1832 partnership of the watercolourist Henry C. Newton with the colour chemist William Winsor was ideally suited to aid the incorporation of the results of developing technologies into the traditionally rooted trade of the colourman. Winsor's scientific training enabled him to recognise that the addition of the recently discovered glycerine to watercolour cakes would increase their solubility. His knowledge of chemistry together with a close association with George Field, certainly the most eminent colour maker of the day, enabled them to evaluate more successfully the new pigments developed by colour makers primarily for purposes other than fine art where durability and permanence may have mattered less, for example, in the dyeing industry.

In 1888, following an inquiry into the action of light on watercolours, Winsor and Newton published a policy statement together with the details of the composition and permanence of their colours. These details were based on the results of experiments they carried out on their colours. The colours were tested for fading by

exposing them to normal light conditions in a well-lit room with a northerly aspect. Classified lists were prepared on the basis of the results of the tests. The policy statement points out, following Fields precepts, that 'as long as artists' demand colours such as Carmine or Geranium Lake, we will continue to supply them . . . we as colourmen, do not assert that such colours are durable; all we do assert is that they are as durable as they can be made'.

While maintaining production of the more traditional colours and media, colourmen have also created new, more satisfactory colours for artists. Winsor and Newton introduced Chinese white, a more opaque form of zinc white, which had for over a hundred years been the only white colour suitable for use in watercolours. Colourmen have also introduced new media. In the 1960s colourmen provided ranges of ready-made polymer emulsion paints, acrylics, which followed the demand of artists, who a few years earlier had started to grind pigments in commercially available resin emulsions. In the 1970s, Winsor and Newton introduced Alkyds which are intended as an alternative to oil paint. The trade has also developed the range of artists' canvases, experimenting with a variety of woven textiles and primers.

As well as manufacturing paint the colour-men also make and supply a vast range of artists' materials, some traditional and others innovative, such as brushes (p.69), varnishes, oils, as well as equipment like colour boxes and easels to artists, who require a large selection to satisfy very individual requirements.

J.M.W.Turner 1775–1851

An Artist Colourman's Workshop c.1807

Oil on pine panel, 62 × 91.5 (24½ × 36)
Tate Gallery 5503

The picture, which is unfinished, was painted on pine panel. There are horizontal cracks associated with the panel joints caused by the poor quality wood. Details of the construction may indicate that the panel was once part of a door, rather than a specially prepared artist's panel.

The horse-driven wheel in the background is grinding a pigment which can be ground in bulk, while the colourman in the centre grinds a more delicate red pigment with a muller. The vats and jars contain various oils, resins and media. The utensils for mixing media, mixing bowls and cauldrons etc., are also shown.

Permanence

Although artists' colourmen have identified and developed reliable materials, only competent handling of these materials by informed artists can ensure a satisfactory result. All materials have intrinsic limitations and these may be exacerbated by thoughtless applications, but here we see for the most part those careful and restricted techniques which have proved to be successful. The paintings by J. F. Lewis and G. Stubbs illustrate a high regard for permanence, the former through cautious and meticulous application, the latter through the use of stable materials. Stella shows how to choose a suitable support whereas Roth clearly aims at impermanence. The painting by Van Gogh is an example of pigment fading because of excessive light. Many other paintings in the exhibition illustrate various aspects of permanence.

John Frederick Lewis 1805–1876

Study for the Courtyard of the Coptic Patriarch's House in Cairo c.1864

Oil on panel, 36.9 × 35.5 (14½ × 14)
Tate Gallery 1688

This is a traditional painting using oil paint on a wooden panel and it shows a high level of craftsmanship. The artist has chosen a very stable support of a good cut of well seasoned wood. Quarter sawn (radial) timber from a mature straight tree, preferably the mahogany type or walnut, are the least prone to cracking or warping. He has applied a thin light-coloured oil ground followed by an extremely thin paint film. There is little impasto and each colour is laid directly on to the ground to take advantage of its reflective properties. The colours will have changed very little, although the varnish has yellowed slightly. There are no cracks in the paint film. Incidentally the frame is also an example of outstanding craftsmanship.

Note : other works by J. F. Lewis e.g. 'The Siesta' (Tate Gallery 3594) are also in good condition.

George Stubbs 1724–1806

Lion and Lioness 1770

Enamel on copper, 24 × 28 (9½ × 11)
Private collection

From about 1769 onwards Stubbs embarked on his experiments with enamel painting, possibly motivated by observation of the deterioration in his earlier works. He undertook to create works that would maintain their pristine condition almost indefinitely, by employing materials known for their permanence.

Copper was chosen as the support because it is inert, insensitive to moisture and not fragile.

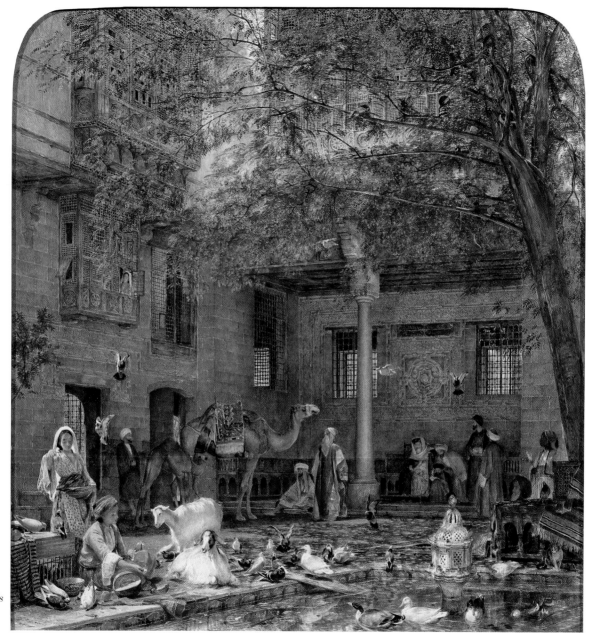

F. Lewis
dy for the
rtyard of the
ptic Patriarch's
use in Cairo
864

George Stubbs *Lion and Lioness* 1770

The surface of the copper was scored and cleaned to assist adhesion, and a ground of white metal oxide (almost certainly tin) mixed with silica, and a flux of borax and lead was applied and fired in a kiln.

Stubbs developed nineteen tints which would not change colour on firing. He made up a paste with these tints by adding flux and either turpentine or a gum solution, which enabled him to paint onto the previously fired tin oxide glaze. This would have been similar to painting in thick gouache. The painting was then fired to produce the enamel.

The technique had strict limitations which would have inhibited many artists, however Stubbs was prepared to master them in order to achieve permanent images. His own oil painting technique was very disciplined so he would not have found the new medium too demanding. Stubbs further developed the technique by working on large 'earthenware biscuits' made by Josiah Wedgwood's company.

The painting is virtually unchanged since firing. The glossy surface required no potentially discolouring varnish and the enamel medium is stable under nearly all normal conditions so Stubbs can be considered to have been completely successful in his aim.

Vincent van Gogh 1853–1890

The Oise at Auvers 1890

Gouache on paper, 47.3 × 62.8 ($18\frac{5}{8}$ × $24\frac{3}{4}$)
Tate Gallery 4714

Here we see a dramatic example of a pigment fading because of excessive exposure to light. Towards the end of the nineteenth century many strongly coloured dyes became available. These were absorbed onto alumina to form lake pigments. Most were not light fast, and it was exceedingly difficult for an artist buying cheaper materials to assess the permanence of all of the materials available for sale. The problem was particularly serious in watercolour or gouache media where the pigments are unprotected by the medium or by a varnish. In this case the area which is normally covered and protected from light by the mount has not faded to the same degree, so the contrast is very obvious. Although this is a dramatic example, many watercolours, particularly those using thin washes, may have faded to some extent, depending on the pigments used. This can sometimes be discerned by the unexpected absence of a colour such as indigo or gamboge. This is a reason for exhibiting watercolours for short periods and at minimum light levels.

Frank Stella b.1936

Guadalupe Island, caracara 1979

Mixed media on an aluminium honey-comb support, 238 × 307.5 × 40.5 ($93\frac{5}{8}$ × 123 × $15\frac{7}{8}$)
Tate Gallery T.3058

This is an example of the choice of a stable support to accommodate a variety of techniques and mediums. Stella has selected and

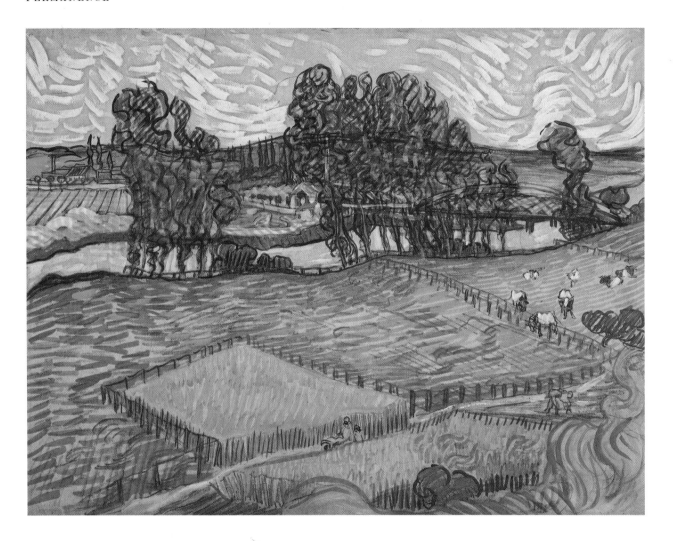

Vincent van Gogh *The Oise at Auvers* 1890

Frank Stella *Guadalupe Island, caracara* 1979

modified the support to suit his particular needs. Earlier in his career he used conventional canvas supports but they tended to distort with the application of collage. In his 'Brazilian Series', begun in 1974, he used honeycomb aluminium for the first time, and this became his main support for his subsequent large work. Honeycomb aluminium was developed for use in aircraft and satellites where strength and lightness are important factors. It is a very stiff material for its weight and its panel construction allows it to be cut, with a band saw, into any shape and still retain its stiffness. The honeycomb panel is unaffected by humidity changes (unlike wood). The panels are bolted together with brackets and plates so that they can easily be dismantled for transportation.

Since aluminium does not readily receive a paint film, the aluminium was prepared by etching the surface with caustic solution. Epoxy resin was then applied to protect the aluminium and ensure that the paint films adhere adequately. Each of the cut panels were painted separately and then assembled. In contrast to his careful preparation, Stella used a variety of media which included lacquer-based silk screen inks, Magna (white spirit based acrylic paint), Aquatec (a water-based acrylic paint) and Bocours Pearlescent White. The texturing materials Stella used were ground glass, anodized aluminium glitter and reflective beads. The adhesion of the glitter is poor. The calligraphic marks, applied in broad vigorous scribbles were in oil and lithographic crayon, mostly applied after the paint layers. Stella's

variety of techniques, materials and methods of application in this work combine to make a demanding test for any painting support. It remains to be seen whether this highly stable honeycomb material will prove to be completely satisfactory, but at least the support that Stella has chosen is probably the best available (ed. Hackney 1982 p.114).

Dieter Roth b.1930
Self Portrait at a Table 1973–6

Mixed media on board,
73.2 × 108.6 ($28\frac{3}{4}$ × $42\frac{3}{4}$)
Tate Gallery T.2210

Roth has avoided the problem of permanence by deliberately constructing a work of art which he expects will change in appearance. He has used many everyday materials such as cardboard, plastics, woodworking adhesive, even butterfat and chocolate in addition to oil and acrylic paint. He has incorporated his paint brush, a plastic spoon and fork (of the type supplied with air-line food), and some printed adhesive tape. At the bottom right there is a lump of chocolate and this already shows signs of deterioration. Clearly, all the materials employed by Roth will change in appearance over a period of time, but he is not concerned with producing a fixed image. The work does not depend on precise colours, tones or harmonies and will retain its meaning when these have changed irrevocably.

Dieter Roth *Self Portrait at a Table* 1973–6

Artists at work

This section illustrates artists and their equipment, at work in the kind of light conditions favoured by them. Before the nineteenth century artists preferred to work in the controlled light conditions of the studio. During the nineteenth century painting in natural daylight, often out of doors, became increasingly popular, although many painters brought their work to completion in the studio.

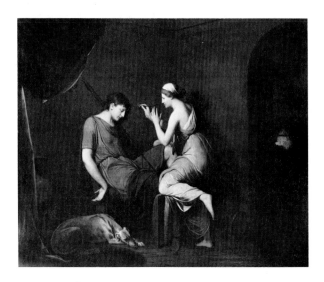

Joseph Wright of Derby *Corinthian Maid* 1782–4

Joseph Wright of Derby 1734–1797

Corinthian Maid 1782–4

Oil on canvas, 106.7 × 127 (42 × 50)
Paul Mellon Collection, Virginia

This painting depicts the delightful Greek legend of the origin of painting. A Corinthian maid, Dibutade, knowing that her lover is to depart, traces his silhouette on a wall as an amorous memento.

Jan van der Straet (Stradanus) 1532–1605

Painting in Oil c.1600

Engraving from *Nova Reperta*
(photograph exhibited) British Museum

Stradanus's engraving of a painter's studio shows the organisation of a Renaissance workshop. The master painter puts the finishing touches to the canvas. On the right two journeymen grind the pigment on a slab: first dry, and then with water using a muller. According to Cennini the ideal slab and muller for grinding pigment were made porphyry. To make oil paint the wet pigment was dried, and then mixed with a spatula or palette knife with sufficient oil to make an easily workable paint. The assistant seated on the right may well be testing the paint to see that it has been thoroughly mixed.

On the left an assistant prepares the painter's palette taking the paints from small pots and shells in which oil paint was stored by artists (as

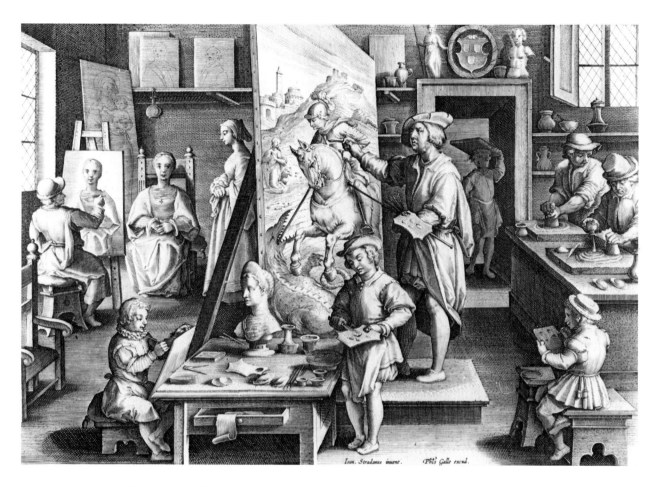

Jan van der Straet *Painting in Oil* c.1600

well as in bladders [p. 68]). The standard equipment, palettes, brushes and dividers are laid out on the table. On the far left an assistant is painting the portrait of the seated lady. Another assistant practises drawing the classical bust on the table in front of him.

A mahl stick is held by the master painter, the end of which was usually covered by leather, rests on the painting. It was used to steady the painter's wrist, when precision of touch was required (Constable 1954 p.25).

Baccio's apprentices, others noblemen, who gathered together socially with the sculptor to enjoy drawing and the discussion of the theory and practice of art.

Enea Vico 1523–1567

Baccio Bandinelli's 'Academy' in Florence c.1550

Engraving, (photograph exhibited)

Baccio Bandinelli was a famous Roman sculptor. Pope Leo X gave him apartments in the Belvedere Courtyard in the Vatican, where he could work. An engraving by Agostino Veneziano of 1531 records the Academy of Bandinelli in the Belvedere. Twenty years later Bandinelli settled in Florence, and there too he formed an 'Academy' engraved by Enea Vico.

Several elderly and young men are shown in a magnificent room with a fine fireplace engaged in individual study. 'The Academy' was far from the organised institution, which we have known since the eighteenth century. There are no signs of any master-pupil relationships. It was rather a group of men, some may be

Pietro Francesco Alberti 1584–1638

The Painter's Academy

Etching, (photograph exhibited)
British Museum

By the seventeenth century drawing classes were well established in the academies in Italy. The students were taught the basic skills of drawing, geometry and anatomy. Anatomy was studied thoroughly. Physicians often carried out dissections at the Academies (in the right background). In the foreground a student

faithfully renders the skeleton (a favourite art school prop [p. 56]). Other students draw from plaster casts, practice geometrical figures, or square-up a canvas.

Belvedere' to sharpen the contours, as suggested by Symonds (p. 75).

Attr. to Johann Zoffany R.A. 1734–1810

The Antique Room at the Royal Academy 1780–3

Oil on canvas, 106.8 × 163.8 (42 × 64½)
Royal Academy of Art

This painting shows the Royal Academy in its original quarters in Somerset House. Students under the eye of a teacher are drawing from casts taken from antique statues, which include the 'Apollo Belvedere' and the 'Torso Belvedere'. Both statues are lit by lamps and there is a screen inserted behind the 'Torso

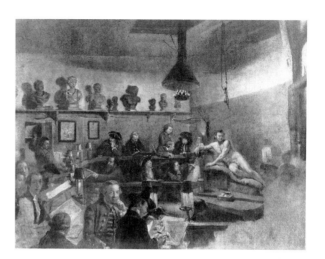

Joseph Wright of Derby 1734–1797

An Academy by Lamplight c.1769 unfinished

Oil on canvas, 45.7 × 50.7 (19 × 25½)
Royal Academy of Art

Wright enrolled as a student of the Royal Academy on its foundation in 1768, when he was already a well-established painter. The painting shows the students drawing from a live model, as opposed to casts from antique sculpture.

Samuel Butler
*Mr Heatherley's Holiday:
an Incident in Studio Life*
1874

Samuel Butler 1835–1902

Mr Heatherley's Holiday:
an Incident in Studio Life 1874

Oil on canvas, 92 × 70.8 (36¼ × 27⅞)
Tate Gallery 2761

Samuel Butler, the philosophical writer,
amateur artist and composer studied painting
at South Kensington, Cary's, and Heatherley's
School of Art. The Art School which
Mr Heatherley ran in Newman Street had the
same props as Academies – casts from antique
sculpture, and skeletons for the study of
anatomy. At Mr Heatherley's school the
skeleton 'was always getting knocked about
and no wonder, the students used to dress it up,
and dance with it – Mr Heatherley never went
away on holiday; he employed the time at home
repairing the skeleton' (H. Jones, *Samuel Butler*
1919 p.201).

From the early nineteenth century there was
a growing feeling that painters required a
ground work of technical knowledge. This was
reflected in the report of a committee set up in
1835 to examine the connection of the arts and
manufacture. The report reflected a dissatisfac-
tion with the limitations of art education, which
was restricted to fine art, although industry had
an expanding need for designers. The com-
mittee helped to bring about the establishment
of schools of design with the purpose of gaining
closer collaboration between art and industry
(Harley 1970 p.175).

Francis Cotes 1726–1770

Paul Sandby 1761

Oil on canvas, 125.1 × 100.3 (49¼ × 39½)
Tate Gallery 1943

Paul Sandby (1732–1809), one of the founder
members of the Royal Academy, was a lecturer
at the Woolwich Academy, a Military
Academy. In these Academies men were taught
to draw accurate topographical maps and views
of the places they visited on their voyages, as
well as recording battles. Soluble inks which
were fugitive to light had been used for these
paintings. Sandby approached the colour
makers Middleton's for some colours which
were more permanent and solid for this kind of
work. They prepared colours for Sandby made
from pigment ground in gum arabic. The colour
was then dried in rough lumps. These were more
easily transportable. They were grated and then
mixed with water before painting.

The artist is shown sketching out of a
window, leaning on a portfolio. Sketches made
outdoors, both of whole compositions, and
vignettes of landscape or architecture would be
used in the studio for paintings. The same
sketches would often be re-used for several
paintings. Boucher's 'Artist in his Studio'
(Louvre) shows him studying an architectural
sketch (of a tower) from his album, which he is
using for the painting on the easel (p. 73).

Francis Cotes
Paul Sandby 1761

the rain, which heightened the green of the remaining grass, together with the brown of the hay. The consequence was an effect of unusual beauty of colour, making the hay by contrast with the green grass, positively red or pink under the glow of twilight.' The beauty of the landscape, and the colour inspired the painting. Brown is shown resting, with his paints, palette and sketching stool laid aside, surveying the scene at moon rise.

Ford Madox Brown 1821–1893

The Hayfield 1855–6

Oil on panel, 24 × 33.2 ($9\frac{1}{2}$ × $13\frac{1}{8}$)
Tate Gallery T.1920

This painting, begun on the 28 August 1855, was painted in part outside at Hendon as well as in the studio. The landscape was painted at Hendon over several months. He wrote 'the weather has been most trying: However I have stuck at it, sometimes walking for fourteen miles and only getting two hours work in'. The cart was sketched at Cumberland market and inserted into the composition in the studio later. It must have been completed by 21 January 1856, when the dealer White saw it but disliked the pink colour of the hay.

In the catalogue of his exhibition at 191 Piccadilly in 1865 Brown recalled, 'stacking the second crop of hay had been much delayed by

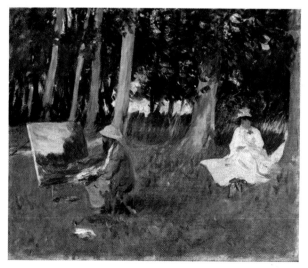

John Singer Sargent 1856–1925

Claude Monet Painting at the Edge of a Wood 1888

Oil on canvas, 54 × 56 ($21\frac{1}{4}$ × $25\frac{1}{2}$)
Tate Gallery 4103

Sargent regularly visited Monet at Giverney in the later 1880s, and painted him several times. The picture on his easel in Sargent's painting, can possibly be identified as 'Meadow with Haystacks near Giverney' of 1885 (Museum of Fine Arts, Boston).

Monet always began his landscapes out of doors in front of the subject, as he sought to capture the fleeting effects of light around him. The canvas on his easel in Sargent's painting seems to be simply and broadly laid in; 'Poplars on the Epte', in the Tate Gallery is a good example of such a canvas which he painted rapidly, perhaps entirely out of doors, without reworking it extensively. However his exhibition paintings of this period were consistently retouched in the studio, and their colour and brushwork much elaborated. He felt by this date, that his fully finished paintings should be more than mere sketches, and he was rarely able to bring them to this state out of doors

before the natural effect changed. 'Antibes' (Courtauld Institute Galleries 1888) is an example of such a finished canvas.

John Singer Sargent 1856–1925
*Miss Eliza Wedgwood and Miss Sargent Sketching c.*1908
Watercolour, 50.5 × 35.5 (19¾ × 14)
Tate Gallery 3658

After 1905 Sargent went abroad every autumn on sketching expeditions with his sister. This charming portrait shows Miss Sargent, brush held between her lips at her sketching easel and beneath her sketching umbrella. The sketching umbrella was used not so much for shelter from the weather, but rather to prevent distracting reflection of light.

John Singer Sargent
*Miss Eliza Wedgwood and
Miss Sargent Sketching*
*c.*1905–14

Artists' equipment

Drawing Instruments

Engraving from Diderot, D. and D'Alembert, J. *Encyclopédie . . . Le Dessein* 1754–63 (photograph exhibited)

This engraving shows the drawing instruments and accessories which were normally used by artists. Such instruments were supplied by colourmen and many painting boxes were fitted with them. The plate shows: Fig.1, the chalk or crayon holder which was often made of brass. Crayon is usually composed of pigment in oil or wax. They were first used in Italy in the mid-sixteenth century. Traces of crayon are found in the work of Tintoretto and the Bassano family (Gettens & Stout 1966 p.288). Fig.2 a piece of chalk. Fig.3 the stump, which is made of tightly bound chamois leather and used to blend shadows. Fig.4 is a quill drawing pen, these were usually made from goose or turkey feathers. Steel pens were made by Samuel Harrison of Birmingham in 1780, but they were not on the market until 1803 (op.cit. p.304). Fig.5 a knife to sharpen the crayon. Fig.6 a compass, this has been a painter's tool since late antiquity. Cennini speaks of their use for incising haloes (Thompson 1936 p.85). They were commonly used to control the parallels and perpendiculars in perspectival settings. Figs.7 and 8 are brushes for use with ink or bistre washes. Fig.9 a pot for water. Fig.10 a

Drawing Instruments
Engraved from *Encyclopédie . . . Le Dessein* 1754–63

block of Chinese ink. Fig.11 a shell for thinning the ink or bistre. Fig.12 a ruler. Figs.13–17 show studio equipment – an easel, a rotating stool for the model, a portfolio which was also used as a surface for drawing, with it resting on the knee and a reduction frame.

<center>*　　*　　*</center>

A stylus of metal was a common tool for drawing from ancient times. Styli of gold, copper, silver and lead were all used. Because of the numerous references to silver point in the literature, frequently no distinction is made among the metals and they are often all referred to as silver point. Drawing with a metal point depends on the preparation of the ground (frequently prepared with chalk and then size) and its ability to hold a small deposit of the metal as it is drawn over the surface (Gettens & Stout 1966 p.297).

Lead point drawing was used in the same way as silver point. The 'lead' point which is used for drawing and writing today is made by firing graphite with clay at high temperatures. It is difficult to know when graphite began to take the place of lead, R. Borghini in his *Il Reposo . . .* (Florence 1586 p.139) describes the use of a lead which may be graphite. The graphite sticks (or leads) would have been put into a holder. It was not until the late eighteenth century that anything like the graphite pencil (graphite enclosed in wood) as we know it came into use as a drawing instrument (op. cit p.292).

Richard Symonds 1617–1692

Secrete intorno La pittura vedute e Sentite dalla prattica del sig. Giovanni Angiolo Cannini in Roma 1650, 1651, 1652

Notes on paintings seen and heard in the studio of Giovanni Angiolo Cannini
British Library, Manuscript Egerton 1636

This little notebook written in a mixture of Italian and English is by Richard Symonds, a royalist, who was in Italy from 1650–52. The notes are based on his observation of the practice of Giovanni Angiolo Cannini, and they record Italian seventeenth-century working methods. The notes include information on priming, colours worked in oil and fresco, artists' equipment, and the setting of the palette, as well as a day-to-day account of Cannini painting his 'Anthony and Cleopatra'.

This is the first seventeenth-century source which gives a description and illustration of the compact box which the artist took with him to paint in oils. Such boxes certainly existed, because biographers of the period record that Salvator Rosa, Claude Lorraine and Gaspar Dughet made oil sketches on the coast and in the countryside. The box drawn by Symonds shows: A, the canvas held taut inside the lid and B, the groove to hold brushes. The box is divided into three compartments, the first, C, to hold the oil glass; the second, D, to hold paint rags and the third, E, to hold the rectangular

palette. Artists, when painting outside, most probably also took with them the three-legged sketching stool, sketched by Symonds and described as 'Tripos to sitt on' (Beal 1978).

Richard Symonds
Notes on painting . . .
(British Library)

J.M.W. Turner's Watercolour Box

Jappaned tin, 9 × 34 × 23 (3½ × 13⅜ × 9)
Tate Archive (7219)

Analysis of Turner's watercolour box has revealed several chrome yellows, cobalt blue, blue verditer. Traditional pigments such as chalk, Indian red, madder, yellow, ochre, vermilion, Venetian red, raw sienna, were also found, as well as fugitive materials such as gamboge, mercuric iodide, quercitron and carmine. The 'modern pigments' present are chrome yellow and cobalt blue, the latter of which he found 'good enough' to compare with French ultramarine. Chrome yellow was the first strong fairly permanent yellow to become readily available. Good blues and reds were by then available, and so the commercial production of chrome yellow (after 1818) completed the spectrum for the artist. It is not so widely used today because other more permanent yellows are available.

Sir Joshua Reynolds' Easel

Mahogany, 188 × 94 (74 × 37)
Royal Academy of Art

This is an elegant version, appropriate for use in the studio of a fashionable artist, of the conventional three-legged easel. This design, with a horizontal ledge running across two parallel legs, to hold the painting, while a third leg swings back to alter the angle of the painting, was used in Roman times.

There is another kind of easel known as the Studio Easel which is designed for large paintings. It has two uprights inserted into heavy feet. The uprights have rungs into which pegs can be fitted to hold the paintings.

Sir Joshua Reynolds' Sitter's Chair

Mahogany and leather, height: 102.8 (40)
Royal Academy of Art

Sir Joshua Reynolds' Painting Table

Mahogany with brass fittings,
78.7 × 91.4 × 61 (30⅝ × 36 × 24)
Royal Academy of Art

The top of the table lifts up to form the support for canvas or paper. The front of the table can be pulled forward and the drawer has partitions to hold pigments, media, oil rags, brushes etc. A flat surface pulls out above the partitioned drawer, and Reynold's may have used this as a surface for mixing colours. The table is set on castors for mobility, and could be seen as an early version of the modern paint trolley.

The Hour Glass

Walnut, glass and sand
27.3 × 13.3 (10¾ × 5¼)
Royal Academy of Art

The hour glass was used in the life classes at the Royal Academy. Since it takes seven minutes for the sand to run through, it was probably used to time the model's break.

Constable's Palette c.1835–7

24.8 × 40.7 (9¾ × 16)
Tate Archive (S.I.81)

Technical analysis of a palette at the Tate Gallery has shown vermilion, emerald green, chrome yellow and madder to be present. Emerald green and chrome yellow were both introduced in the early nineteenth century.

However recent analysis at the Tate Gallery of 'Flatford Mill' has revealed that the greens for which Constable was famous, were found to be a mixture of Prussian blue and yellow ochre, colours which had long been available. Raw and burnt sienna were also present. These were probably mixed in later on the palette to modify the green for use in the composition.

* * *

One of the most traditional pieces of artist equipment is the palette, the surface upon which a painter lays out and mixes his oil colour. Usually palettes can be held firmly in the hand, though many modern painters, Whistler for example, have preferred to use the top of a painting cabinet or table. There are three standard shapes for the palette, the rectangular, long handled and oval palette, and all have a long history. They are most commonly made in cherry wood or walnut.

The term 'artist's palette' also has another meaning. That is, the range of colours selected by an artist for a painting. A selection from the range of available colours is laid onto the palette in a sequence that facilitates colour mixing. When paint was prepared by hand for use over several days, storage of the paint once laid out on the palette was a problem. Symonds (p. 63) recommends if too much colour has been laid on the palette, that the 'palettes are placed in water, just as they are set in order, that the colours may not dry when the painter wishes to

Constable's palette *c*.1835–7

use them the following day'. But colours which are spoiled by water such as verdigris, red and yellow lakes or toxic pigments like white and red lead should be removed and stored in cockle-shells covered with oiled paper (Beal 1978).

After the invention of the collapsible tube the artist could more liberally arrange his colours on the palette without fear of wastage.

Queen Victoria's Oil Colour Box

Mahogany inlaid with tortoishell and ivory, $15.2 \times 52.7 \times 38$ ($6 \times 20\frac{3}{4} \times 15$) Royal Academy of Art

This handsome box, presented to Queen Victoria by her mother, is one of the few surviving examples of a box fitted with

syringes, similar to those designed by James Harris. The metal syringes, inscribed for specific colours, are in perfect condition, empty and unused (Harley 1971).

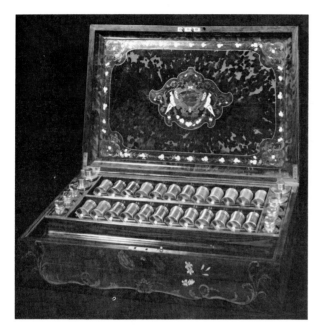

Queen Victoria's oil colour box

THE COLLAPSIBLE TUBE

Until the early nineteenth-century oil colours had been supplied by colourmen in skin bladders which were drawn together at the top, and tightly bound to exclude air, enabling the artist to avoid the time consuming job of hand grinding. When a painter wanted to use the colour he punctured the bladder with a tack, and plugged up the hole with a tack or bone

plug after use. The disadvantages of bladders were numerous, some colours deteriorated in storage, all colours hardened when the bladder was punctured, and they tended to burst.

Since oil paint was costly, a more efficient means of storing prepared colour was required. In 1822 a design was submitted to the Royal Society of Arts by James Harris for a metal syringe container. On one end, the syringe had a nozzle fitted with a cap to close the syringe when not in use, and a screw at the other end served as a piston rod to push the paint through the nozzle. The disadvantage of metal syringes lay in their expense, this made them unlikely to become popular with the amateur; though professionals, like Sir Thomas Lawrence ordered a set, and Queen Victoria was given a set by her mother. The syringe tube was developed further by Winsor and Newton who in 1840 patented a glass syringe. This was an improvement on the metal syringe, it was both cheaper and transparent, though breakable. On the whole the press took a favourable view and saw the invention as likely to encourage ladies to paint in oils (*Art Union* 1840). Until then the skin bladders bursting and spilling over their clothes, had presumably been a deterrent to all but the most dedicated amateur.

In 1841 an American John G. Rand, a fairly fashionable portrait painter in London, devised the first collapsible tube. The invention was announced by the colourman Thomas Brown, 163 High Holborn, as 'Brown's Collapsible Tube . . . which effectually prevents all waste, dirtiness and smell; and will preserve the colour

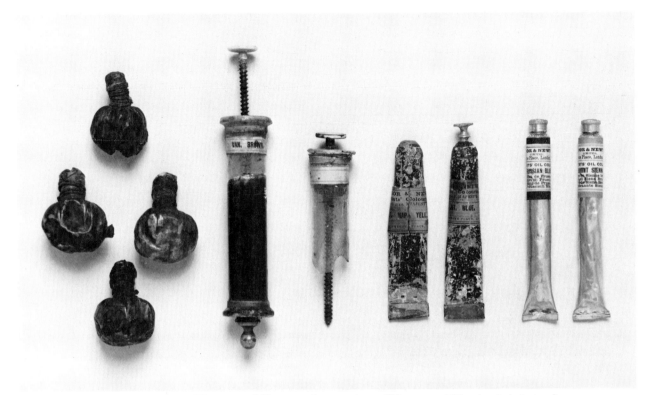

Oil paint stored in pig bladders, Winsor and Newton glass syringe, Winsor and Newton's tube and Rand's collapsible tube

for years'. The tubes were made by the extrusion of a metal under sudden pressure of a cold metal press. That means that a soft metal die made from tin, lead or aluminium was forced to flow into the required shape under the blow of a tube-shaped punch. At first they were manufactured by hand operated presses. Empty tubes were available from Browns, to other colourmen, who were however reluctant to use tubes marked with Brown's name as a container for their own products.

Colourmen immediately recognised that the tube was the ideal solution to the colour container. Winsor and Newton began to make their own tubes, by rolling thin sheets of metal. These tubes had stoppers rather than screw caps, and were less satisfactory than Rand's tube because of paint seepage. Meanwhile they were involved in negotiations with Rand to market his tube. In 1842 Rand announced to the press that his tube, which had hitherto been known as Brown's Patent Tube could now be

sold by Winsor and Newton as Rand's Patent Collapsible Tubes, for wholesale, retail and for export. This arrangement must have been very satisfactory for Rand, Winsor and Newton and other colourmen, who could then use the tube without advertising another colourman.

The collapsible tube provides ideal storage for oil paint. It made painting easier, especially outdoors, and much more economical for the amateur, who uses his paints far less regularly than professional artists. Paint supplied in the tube was almost universally adopted by artists, although colourmen continued to supply oil paint in bladders for more traditionally inclined artists (Harley 1971).

BRUSHES

Brushes for holding and applying paint probably existed in some shape or form since the birth of painting in prehistoric times.

Until the recent introduction of synthetic fibres, brushes in the West fell into two categories: hard brushes, usually made from hog's bristle, and soft ones, made from the hair of a variety of animals. During the seventeenth and eighteenth centuries most relatively small brushes were called 'pencils' in English and described as either 'pointed' or 'fitched', the latter meaning 'square headed'. The word 'brush' was generally reserved for large brushes employed for priming pictures and painting frames (Harley 1976 p.63).

Hard brushes of that period and earlier were generally made by binding bristles to the brush handle with cord, to make a round brush, the top of which could be cut square if desired. The modern flat bristle brush only appeared in the early nineteenth century, with the advent of metal ferrules which could be flattened with pliers. The variety of such ferrules greatly expanded the range of brush shapes, to include for example large soft fan shaped ones for softening and glazing.

In earlier times soft brushes were usually made by binding and fitting the hair into a quill, usually of a water fowl, as this was more resistant to water. Into the quill was inserted a handle of wood or bone.

Some medieval and Renaissance sources gave directions for making brushes (Cennini 1933 p.40f). By the sixteenth century however most artists bought their brushes ready made, and in 1587 Armenini thought that the best came from Venice (Armenini 1587 p.111). About seventy years later Richard Symonds (p. 63) saw bristle, polecat, badger and 'miniver' brushes in use in Rome, and described how they were used (Beal 1978 p.74).

Bristle brushes, although less flexible than soft hair brushes, were ideally neither excessively coarse nor hard, and painting a rough wall was recommended as a good way to break them in. Sizable bristle brushes were used extensively for fresco painting and for applying the ground and blocking in the first broad areas of colour in an oil painting.

Softer and more supple brushes were generally

made from the hair of the polecat. Full, probably square-headed polecat brushes were frequently used to blend together colours in an oil painting and to soften harsh contrasts of light and shade, when painting a face for example. Badger brushes were also used for this purpose, but probably less often as they were comparatively expensive.

For fine delicate work in oil, watercolour and tempera, and for finishing touches, many sources like Symonds recommended soft 'miniver' brushes, a name thought to signify ermine or a mixture of ermine and weasel. Miniver brushes varied in shape and size. Symonds noted that long, narrow pointed ones were used to paint plants and flowers as well as the fine rigging of ships in seascapes, hence the later term 'rigger' for this type of brush. Small pointed miniver brushes were used to pick out fine details of the face and hair in portraits. Today such brushes are usually made from red sable, the tail hair of several species of Asiatic minks. Surprisingly sable brushes are not mentioned in art literature until the end of the eighteenth century, when they were on sale in England, together with the somewhat inferior squirrel hair brushes, the latter known confusingly as 'camel hair' (Harley 1976 p.62).

All the brushes mentioned above were chosen and treated with great care. Many sources mention the practice of squeezing a brush between the fingers to test its point and those which shed their hairs were considered useless. During painting sessions artists usually employed a wide variety of different brushes

and after use these were invariably cleaned with turpentine, nut or linseed oil to keep them supple. On some occasions they were finally soaked in spike oil or swathed in a strong smelling herb like tobacco, to ward off moths.

CANVAS

Painting on woven fabric supports has a continuous tradition that goes back to Ancient Egypt. In Europe little survives prior to the fifteenth century due to a combination of factors: the vulnerability of the support – the methods employed to prepare it, particularly the use of size and perhaps the use of aqueous media.

The earliest surviving paintings on canvas were executed in an aqueous medium (gum or size), on fine linen. Dieric Bouts 'Entombment of Christ', c.1455 (National Gallery, London) exemplifies this technique. In Italy, works by Mantegna from the second half of the fifteenth century recall Netherlandish methods. Apart from conventional paintings, canvas was also used for banners, temporary decorations for public events and painted substitutes for tapestry.

The technical innovation was not the use of canvas but painting in an oil medium on canvas, and it occurred first in Italy. An early example is Paolo Uccello's 'St George and the Dragon' (National Gallery, London). It was an innovatory, perhaps experimental, work. During Giorgione's and Titian's lifetimes oil on

canvas became the predominant technique in Venice.

Vasari noted this development and suggested entirely practical reasons for it: unlike wood, canvas did not split or harbour worms; it could be obtained easily in the desired sizes and it was light and easy to transport. These stated practical considerations accompany a profound change in the subject matter and function of paintings, which became increasingly secular. That must also have affected painting techniques and the choice of materials. It is striking that no purely aesthetic considerations have been recorded. The use of coarser weaves and different weave patterns introduced greater textural variety into Venetian painting and artists must have made a personal selection. However, paradoxically, an examination of canvases selected by Tintoretto failed to reveal any consistency. Often his canvases are made up of pieces sewn together with apparent indifference to the location of seams, direction of weave or patchwork finish. Similar problems can be found in Northern painting, for example in Rubens' work. Ford Madox Brown's 'Take your Son, Sir' (p. 96) is another example of a patchwork assembly.

Between 1839–54 power looms for flax weaving were developed in Britain and it is reasonable to assume that machine-woven linen canvas for painting would have been available from this date. Winsor and Newton's catalogues from 1840–1900 exemplify the steady expansion of the variety of weave types and weights available in prepared canvases. During and after the Second World War the selection was drastically reduced.

Traditionally the canvas was prepared in the artists' own studio by assistants. The usual procedure was to stretch the canvas on a wooden strainer or stretcher evenly and systematically aligning the weave. It was then sized with animal bone or skin glues to control the absorbency, and pumiced to remove knots in the weave. Finally the ground was applied. From the end of the seventeenth century rolls of ready prepared canvas were available and from the nineteenth century canvas could also be bought ready stretched. The traditional practice to the present day remains the application of size followed by a white or tinted oil ground. When acrylic painting media are used the canvas is prepared with an acrylic ground.

Although linen still predominates some other fabrics have been used by artists. Robert Rauschenberg's 'Hoarfrost' series employs silk, satin and muslin and at least one painting on silk survives from the fourteenth century ('Parément of Narbonne', Louvre, Paris) as well as works by the seventeenth-century painter Guido Reni. In the 1940's Clyfford Still painted on brown and blue demin, a support which sounds as unstable as the blue or black cloths collaged with white that Cennino Cennini (c.1400) describes for wall hangings. Coarse hemp canvas was used by Tintoretto and Poussin as an alternative to linen and continued to be recommended in the nineteenth century. The production of fabrics woven from jute was mechanised during the 1830s and both Van

Gogh and Gauguin used it, presumably as much for its texture as its cost. In England it was first sold as a prepared canvas for sketching by Rowney and Co. in 1913. Winsor and Newton introduced it between 1920–25, but warned that it had a limited life and could only be recommended where price was the prime consideration and the life of the painting immaterial. As an example of the short life of this fibre it is notable that works by Léger, Ernst and Klee on jute canvas painted in the 1910s had already been lined by the early 1950s.

In spite of the early mechanisation of cotton spinning and weaving processes cotton was slow to gain support as an artists' canvas. It was introduced as a cheap substitute for linen by Winsor and Newton 1900–06 but it took another forty years before artists began to use it for its own intrinsic properties such as whiteness, absorbency and burr. The heavier weight cotton ducks are the most popular for painting on. The earliest painting in the Tate Gallery on cotton duck is Conroy Maddox's 'Passage de l'Opéra', 1940. The next is Jackson Pollock's 'Yellow Island', 1952.

Linen and cotton remain the first choice for artists painting on stretched fabrics in spite of the development of new synthetic fabrics such as polyester that may be suitable. The use of linen in particular is often linked with an expressed desire to be aligned with tradition that contrasts with attitudes towards new painting media, pigments or other items incorporated into a painting.

The studio

The artist is shown studying an architectural sketch of a tower, in his album, which he is using for the painting on the easel. Sketches made outdoors, both of whole compositions as well as vignettes would be used in the studio for paintings.

Nicolas François Octave Tassaert 1817–1874

An Artist in his studio c. 1849

Oil on canvas, 46 × 38 ($18\frac{5}{8}$ × $8\frac{5}{8}$)
Louvre, Collection May

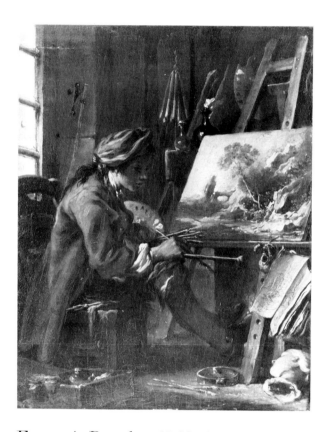

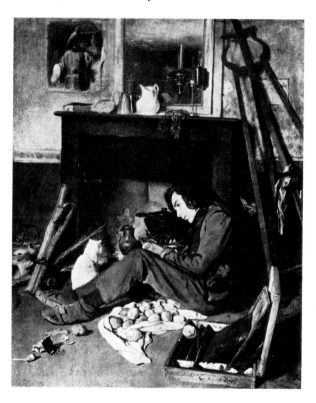

François Boucher 1703–1770

The Artist in his Studio c. 1723

Oil on panel, 27 × 22 ($10\frac{5}{8}$ × $8\frac{5}{8}$)
Louvre, Collection Lacaze

John Piper in his Studio

THE ARTIST'S WORKROOM

From paintings showing artists at work, it seems that artists of the past, like many today, worked in studios that were lit like ordinary living rooms of the period. However, the ideal studio for some was a clean spacious room, with a window high up facing north. This gives a more constant light, which picks out the features of the model clearly. The notion of a light placed high up carried with it an aesthetic value. This is expressed by Padre Lana's comment that 'paintings which are lit from above acquire an inexpressible grace . . . as it is clear in the Rotunda in Rome (the Pantheon), where the high light makes ordinary faces appear almost beautiful.'

In the seventeenth century the windows of artists' workrooms were filled in. Often, they were fitted not with glass panes, but with linen or oiled paper. Symonds (p.63) described the Roman painter Giovanni Angelo Cannini inserting a fine French paper soaked with pork fat into his north window, adding that animal fat was preferable to oil since it yellowed less. Oiled paper or linen windows had been widely used in buildings except the very finest since antiquity. Le Vieil commented that by 1774, in Paris, paper windows were restricted to the studios of painters and engravers. Such windows, he added, deadened sounds from outside, made daylight less piercing, more uniform, restful and similar to evening light (Beal 1978).

Paper windows facing north provided a uniform, diffuse light, but there was also a need to control shadow by using a single light source. Symonds commented that lamplight was best for this because it made the shadow sharp and constant. For this reason, an olive oil lamp hung from the centre of the ceilings in artists' workrooms and academies. Light in the workroom is also conditioned by the colour and reflectivity of the walls. Dark walls were considered suitable, however, if the walls were painted white, Symonds recommends that a piece of coloured paper should be placed behind the model to show the outline clearly (p.55) (Beal 1978).

In the nineteenth century, the practice of painting from models in the studio and in natural light greatly increased. The artist required the north light placed high up to avoid reflection from neighbouring buildings, and to maintain the privacy of the model. During the century many private houses were extended to accommodate these requirements, and blocks of artists' studios were built.

John Everett Millais 1829–96

*Pre-Raphaelite Sketching
Inconveniences in Windy Weather* 1853

Pen, ink and wash on paper, 22.5 × 20($8\frac{7}{8}$ × $7\frac{3}{4}$)
(photograph exhibited)

Sir John Everett Millais 1829–1896

Awful Protection against the Midges
1854

Pen and ink on paper, 16.5 × 10.2 ($6\frac{1}{2}$ × 4)
(photograph exhibited)

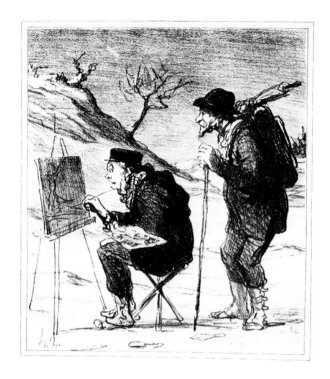

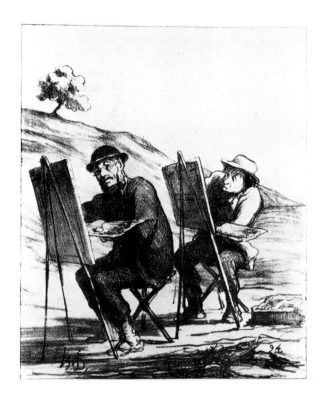

Honoré Daumier 1808–1879

– *Mon vieux, la peinture manque de*
 chaleur.
– *Et le peintre donc!*
– *Old chap, the painting lacks warmth.*
– *How about the painter!*

Lithograph, 1864 (photograph exhibited)
Private collection

Honoré Daumier 1808–1879

Landscape Painters – the First Copies
Nature.
The Second Copies the First

Lithograph, 1865 (photograph exhibited)
Stuttgart State Gallery

Paint media

The object of using paint, whether for artistic expression or in its decorative capacity, is to colour or coat a surface, and at a basic level a paint is a method of applying a coloured compound, the pigment, to that surface. However, to achieve any measure of durability for the paint, the pigment must be bound to the surface. Over many centuries of experimentation, a number of more or less successful binders have been found.

Although Van Eyck (early fifteenth-century) has been accredited as 'the inventor of oil painting' it was in fact the fruition of several centuries of artists' experience. But why should this development be so highly regarded? That oil paint has become the most widely used form of paint since the fifteenth century must indicate a special quality, but what is it? Why should it succeed in the place of, say, egg tempera?

The popularity of oil paint must surely lie in how artists have found it in use, for its handling and its expressive qualities. Consequently, to find answers to these questions the nature of the paint must be considered. In doing this, the differences between oil and watercolour, egg tempera and acrylic emulsion can be illuminated and also why the techniques for each differ so.

The critical difference between one type of paint and another is the medium used. However, the function of the medium is twofold. Firstly it must act as a vehicle, a fluid carrier for the pigment to be applied. Secondly, it must act as a binder, a matrix around the pigment particles holding them permanently in place. The medium must thus have a dual nature – the liquid and the solid. This quality necessarily implies a transition of character: the 'drying' process.

POLYMERS

Now that we have the basic requirements for the medium, what group of substances satisfy these criteria? One form might be for the molecules to create a web of chain-like structures trapping the pigment particles in the interstices of the matted chains. Chain-like molecules are generally called polymers, a term which also covers other extended molecule forms.

Each molecule of a polymer consists of a large number of small building blocks joined together. The building blocks are called monomers and need not necessarily be identical. Polymers made up of different monomers are called co-polymers, and most of the media that are to be discussed could be called this.

For a molecule to be able to act as a mono-

mer, it must have at least two reactive parts to it, otherwise it will be unable to join up successively to form the polymer. More than two reactive parts to the monomer allow it to join up into layers or three-dimensional networks. However, we shall begin by considering the nature of linear polymers.

Although a 'linear polymer' might suggest a rod-like form, it is more likely to take up a purely random shape, and a large number of randomly oriented chains will become matted. Moreover, the longer the polymer chains the more entangled they are likely to be. Hence, as the chain length increases, its viscosity increases.

Using the concept of a polymer, the characteristics of different media in the fluid and solid states can be understood. Although long molecular chains within the paint film are ultimately desirable to give strength, if the polymer molecules are too large in the wet state, the paint will be too viscous. So a high viscosity paint would be difficult to apply by brush. Alternatively, if the polymer molecules are too small, the matrix formed on drying would be inherently weak and the paint would be unstable and impermanent when dry. This rule is particularly relevant to two types of media – acrylic and oil.

There are a number of different acrylic polymers which, as their molecular size increases display greater rigidity. Oils show a similar effect, but are not simple chain molecules. Instead they comprise largely of compounds called fatty acids (because they are found in fats) joined in threes.

HANDLING

Of course, it is advantageous to have each pigment particle completely surrounded by the medium, although excess medium is undesirable, as may become evident later in this essay. A properly bound paint is one where each particle is surrounded by medium which also just fills the interstices between the particles. Paint where there is inadequate medium to cover the particles would be stiff to use, as the medium acts as a lubricant.

Despite this measure of self lubrication, it is usually necessary to further reduce the paint's viscosity to gain the advantage of the larger polymers. There are several ways of doing this. Using thinners and diluents is an obvious solution, but the formation of an emulsion is another.

The utilisation of diluents such as turpentine and spike oil at the time of Van Eyck was one of the reasons which ensured the widespread acceptance of oil paint, which had probably been available for several centuries before. The availability of diluents meant that in the handgrinding of paint the correct pigment to medium ratio for a well-bound paint could be achieved. This is because when grinding reaches the point where the pigment particles are just coated with medium, the paint goes stiff. There is a strong temptation at this point to add too much medium. However with a volatile diluent the artist has complete control over grinding, any excess added can be simply allowed to evaporate.

The other approach to reducing the viscosity of a paint is by making an emulsion. The object is to suspend tiny globules of a polymer of high viscosity (long chain length) in something of low viscosity – commonly water. When a polymer is dispersed in a liquid the polymer is called the dispersed phase, and the liquid the continuous phase. However, a problem arises in that the one is not soluble in the other, and so a third component must be introduced to stabilise the dispersion. This third component is a short chain molecule, with a water-loving end (called hydrophilic) and a polymer preferring end (the hydrophobic end). These molecules cluster around the dispersed polymer particles with their hydrophobic ends, the hydrophilic ends exposed. The whole particle is then apparently water-loving and hence soluble. As the action of this 'third component' takes place on the surface and improves the wetting of the polymer, it is called a surfactant or wetting agent. Soap is of course the classic example of a surfactant. There is an important example among paint media, and that is in egg yolk.

Egg yolk contains a substance called Lecithin, which helps to create an emulsion of fats and oils in a solution of albumen. Egg tempera thus retains a low viscosity during handling and application, and can be diluted with water. On drying the pigment is bound by the long oil chains, which go through an irreversible chemical change that makes the film insoluble in water.

Modern acrylic emulsion paints work on an identical principle. Acrylic monomers are dispersed in water by vigorous agitation, the presence of a surfactant helping to stabilise the dispersion. Then by adding catalysts large molecules of polymer are produced already emulsified. The emulsion can then be slightly modified by, for example, thickening it, to give it exactly the right handling characteristics. Of course, water can still be used as a diluent.

DRYING

Although handling is an extremely important aspect of a paint for the artist, perhaps the most important criterion governing the choice of polymers for media is the drying process. Any polymer used as a medium must exhibit the necessary fluid to solid transition. There are several ways a polymer can do this.

Apart from a substance like wax, fluid at high temperatures and solid at low (which is the principle of encaustic painting), there are broadly speaking two ways of achieving the fluid-solid transition. One is by the evaporation of a solvent, exemplified by the water from the gum medium of watercolour, and the other is by polymerisation within the paint film, exemplified by the drying oils such as linseed oil.

The principle behind solidification by solvent evaporation is extremely simple. A polymer is dissolved in an appropriate solvent, and the solution is applied as a paint. The solvent then evaporates leaving behind the pigment bound in polymer. However, we have already discussed a drawback in this – that ideally the long viscous polymers are to be preferred, for their binding ability. Consequently media based

on solvent loss tend to need plenty of low viscosity solvent to make the paint fluid. Unfortunately this introduces another drawback, in that an appreciable solvent loss from a paint film of any reasonable thickness causes shrinkage of such stress within that film as to cause cracking. The thicker the paint layer, the more prevalent the cracking. For instance this is why watercolour should not be applied thickly.

It was for similar reasons, so the story goes, that Van Eyck invented oil paint. Experimenting with resinous media such as mastic and dammar, which are soluble in turpentine, he found that when his pictures were dried they cracked badly. To avoid this he tried a variety of other things, finally discovering the drying oils.

Drying oils, when unthinned, do not rely on solvent loss by evaporation for their ability to set. Instead the fatty acid chains within the oil link together, creating an extended polymer matrix. The linkage process is, however, different to that discussed earlier where many monomers join to form a chain. When an oil 'dries' a process known as cross-linking takes place. With oxygen from the air, bonds form between the fatty acid chains in the oil creating a three-dimensional polymer structure. To produce a drying oil though, the fatty acids making up the oil must contain a significant number of reactive sites. Those oils with too few reactive sites are semi- or non-drying oils and are unsuitable as media. When cross-linking occurs the fatty acids form a rigid polymer insoluble in the diluents that would previously dissolve the oil.

An advantage of this type of drying is apparent when the paint is used in a thick film such as impasto. Because there is no solvent loss, and hence no contraction on drying, all the brush strokes will remain well defined. The way in which the artist handles the paint will be an integral part of the final image. For a solvent-based paint this can only be true to a much lesser extent.

When a solution of polymer is applied to a surface, evaporation occurs, gradually bringing the polymer molecules closer together. Ultimately the molecules pack together, forming a uniform continuous layer. In the case of a polymer applied in emulsion form, drying begins by a loss of continuous phase (water) by evaporation. It is the polymer globules that are brought closer until they form a discontinuous polymer film. Some gaps remain in the interstices between the particles. The polymer globules must then merge to form a continuous film. However, this can only happen in one of three ways. Either a solvent must be present to soften the polymer, or the polymer surface must be soft and tacky at room temperature (in which case the final film will itself be tacky), or further polymerisation must occur between the polymer globules.

Acrylic emulsion paints begin to dry by losing water, but when the particles come to coalesce, merging is achieved by using acrylic co-polymers which are slightly tacky at room temperature. Unfortunately this does mean that these acrylic films tend to pick up dirt. On

the other hand, the flexibility associated with these co-polymers allows much thicker films to be used, because they can take up much more strain during the loss of a solvent without cracking.

In tempera paint, as the egg yolk dries, water is first lost by evaporation, and then the protein hardens, the oils remaining suspended in a dried albuminous matrix. These oils gradually cross-link and harden. Despite the albumen being slightly water sensitive the excess of cross-linked oil gives the film extreme long term stability. Tempera paint films do not have the flexibility associated with acrylics so can only be used to achieve texture and not impasto, whereas acrylic films will happily take a heavy impasto.

The restriction on film thickness might apparently limit the hiding power of an egg tempera paint. However, the volatility of water combined with a small film thickness ensures that tempera dries quickly, so several layers can be built up quite rapidly. A further consequence of the short drying time is that it is not possible in tempera technique to form a continuous film over an extended area. Rather the technique involves building up a colour with a large number of tiny, hatched brush strokes.

Oil on the other hand takes much longer to dry. Consequently oil technique allows the artist to achieve a continuous film of modulated colour over a large surface area. For the purposes of building up a series of separate layers however, oil is much more restrictive than tempera.

The drying time of an oil film is dependant on film thickness. As the oil needs oxygen to cross-link, it takes much longer for the oxygen to penetrate if the film is thick. The cross-linking process can be speeded up though. Raising the temperature or increasing the exposure to light (especially ultra-violet) helps, but there are also ways of modifying the oil itself. Basically the oil can be modified in two ways: either by partly cross-linking the oil before it is used, or by the introduction of a catalyst.

A catalyst acts by providing an easy 'stepping stone' to polymerisation. The catalysts used to promote drying in oils do so largely by helping in the uptake of oxygen. These are metal 'soaps' formed between a metal and the fatty-acids in the oil. Only certain metals will do this such as manganese, cobalt and lead – which explains why the colours containing these metals, such as cobalt blue and lead white, dry rapidly in comparison to other colours.

Stand oil is an example of a partly polymerised oil. To make stand oil, a drying oil such as linseed oil is heated to about 250°C but with all oxygen excluded. This last factor is most important, because instead of the cross-links forming via an oxygen atom, bonds form directly between the fatty acid chains in the oil. In consequence, the bonds are much shorter, creating a stronger polymer structure. As a dry film, stand oil is also less prone to yellowing and cracking.

Alkyd paints are a modern development from drying oils. The drying and film forming

properties have been altered by incorporating cross-linking resins either to replace or modify the fatty acid component of the oil. As in stand oil this cross-linking does not involve oxygen and does not cause yellowing.

THE DRIED FILM

What though should ideally be expected of a dry paint film? If the paint is to have a reasonable lifetime it must stick to the surface it has been applied to, be hard enough yet flexible to stand up to the test of time. Finally, it should retain its appearance throughout its life.

Adhesion is really a question of wetting – how well the paint will spread on the surface. The best adhesion comes from molecular bonding, but this can only occur if the molecules in the applied paint film achieve very close contact with those in the layer below. Adequate wetting basically comes down to like attracting like. For example two fresh oil films will adhere well to each other. In the case of acrylic emulsions good contact with the underlayer can be improved by the addition of wetting agents to the paint.

The hardness, toughness and durability of a paint film is dependent on the ultimate polymer size after drying. On the whole cross-linking creates a more durable film, although the larger the polymer chain molecule the better the dry film is in these three respects. If the molecular chain is long enough, a polymer will be as hard, as tough and as durable in linear form as it can be in cross-linked form. Egg tempera and oil, which cross-link, tend to be tougher films than acrylic, which does not. Watercolour cannot

really be considered in this manner, as it becomes mechanically caught by the paper surface, never achieving what might be considered a coherent film.

Unfortunately, hardness generally means brittleness. Flexibility can be introduced into a cross-linked structure by spacing out the cross-links. This produces a looser, more open cagework of molecules. Different fatty acids have different numbers of reactive sites within the molecule, and so an oil made up of fatty acids with well spaced reactive site will form a more flexible final film. This accounts for differences in dry film flexibility between, say, linseed, walnut and poppy oils.

Optically, the onus of stability lies largely on the pigment. Media are however responsible for two optical effects during ageing. One is the yellowing of the medium and the other is the apparently increasing transparency of oil paint with time.

Yellowing is caused by coloured groups called chromophores. Chromophores are the result of certain types of atom and bond sequences within molecules absorbing some wavelengths of light. Although oil (for example) has a slight yellow colour to begin with, the increasing degree of yellowness with time is due to the decomposition of the cross-linked polymer film. Some of the decomposition products are highly coloured. Alkyd films suffer from this problem but much less so than linseed oil or even poppy oil. Acrylic films are far less prone to this kind of degradation, and so discoloration is not a problem.

To understand why oil paint becomes increasingly transparent with age, it is necessary to introduce the idea of refractive index.

Refractive index (R.I.) is a convenient way of expressing how fast light travels through a substance compared to its speed through a vacuum. Basically, the slower light travels through a substance the higher its R.I. Air has an R.I. of about one, as light travels through it at roughly the same speed as it would a vacuum. Oils have an R.I. of nearly 1.5, as light travels through them at only about two-thirds its speed in vacuo.

There is an interesting effect from these differing speeds of light. If a beam of light in air strikes the surface of an oil film at a slight angle to the perpendicular, when that beam enters the oil film it travels at a slightly different angle: it has been bent. The same will happen between the oil and a pigment particle of different R.I., in the paint film. If the oil and the pigment have the same R.I., the light beam will not be bent.

Now consider what the effect is going to be when light enters a paint film. We perceive the reflected light. The higher the R.I. difference between pigment and medium the more the incident light is bent, and the greater the chance that it is turned round . reflected. For high R.I. differences, light has less chance of penetrating the paint film and is thus highly opaque. Conversely, low R.I. differences result in a transparent film.

What happens when an oil paint film becomes more transparent is that the R.I. difference between pigment and medium becomes less. Hence, its transparency increases.

I hope it is quite clear by this stage how much of artists' techniques revolves and evolves by virtue of the nature of the medium. Each medium has its own, perhaps unique characteristics. Returning to the series of questions at the beginning about the supremacy of the oil painting medium, we can now see why it was so. Acrylic emulsion paint can never replace oil paint, only displace its popularity, just as oil did with tempera. Ultimately it is the artist's choice as to which medium best expresses what he is trying to say.

Preparatory drawings, sketches and unfinished works

Both the 'Death of Chatterton' and 'Canal Bridge' show how the artist has worked out his composition using line drawings before beginning on the main canvas. By comparing the preparatory sketch with the finished work it is possible to appreciate the development of the final image. In 'Helios and Rhodos' Leighton has planned his final image not in line drawing but in blocks of colour.

The sketches have been included to illustrate how the artist records a scene or visual impression that can be transferred to or incorporated in a finished painting at a later date. These sketches are frequently painted out of doors using portable materials. 'Galera' is in watercolour on paper, 'Goring Mill' 'Loch Avon' and 'Tahitians' are oil sketches, on canvas, panel and paper, respectively.

The unfinished works are useful in that they show the sequence of steps involved in producing the final painting. A comparison can be made between dark and light ground techniques, and also between a careful meticulous approach and a more spontaneous confident style. It is interesting to speculate on the reasons why these works were abandoned.

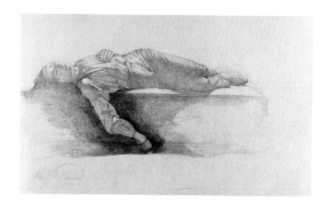

Henry Wallis 1830–1916

Study for Death of Chatterton c.1856

Pencil on paper, 27.3 × 44.5 ($10\frac{3}{4} \times 17\frac{1}{2}$)
Tate Gallery T.1722

This long rectangular sketch in pencil on paper shows Wallis in the process of resolving the model's position. Pencil can be erased so is ideal for the initial attempts to work out an image.

Henry Wallis 1830–1916

Study for Death of Chatterton c.1856

Pen and ink on paper, 19.3 × 25.2 ($7\frac{5}{8} \times 10$)
Tate Gallery T.1721

In another smaller sketch, this time in pen and ink, Wallis has modified the position of the figure. The head is turned further forward, and the position of the chest and hand altered. He has also developed the shadows to strengthen the modelling of the figure. The format of the pen drawing is closer to that of the final oil painting.

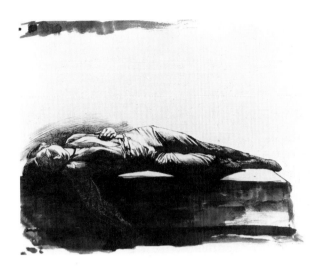

Henry Wallis *Study for Death of Chatterton* c.1856

Henry Wallis 1830–1916

The Death of Chatterton 1856

Oil on canvas, 62.2 × 93.3 (24½ × 36¾)
Tate Gallery 1685

The finished painting has an even white ground, and is quite thinly painted in oil. The position of Chatterton has been changed again. The head droops over the edge of the bed producing a fine sweeping curve through the neck and chest to the hips. There is an alteration to the position of the lower part of the left leg and foot.

The subject of the painting is the suicide of the poet Chatterton (1752–70) who having failed to make a literary career in London, took poison at the age of eighteen. On the picture frame two lines from Marlowe's 'Faustus' are inscribed:

'Cut is the laurel branch that might have grown straight.
And burned is Apollo's laurel bough'

Wallis used the poet George Meredith as the model for the painting.

Harold Gilman 1876–1919

Canal Bridge, Flekkefjord c.1913

Pen, black ink on paper, 23 × 29 (9 × 11½)
Tate Gallery T.26

Probably made on one of his travels in Scandinavia in 1912–13, this heavily annotated pen and ink drawing on paper is one of the

Henry Wallis *The Death of Chatterton* 1856

studies from which the final painting was made in the studio. The sketch is half the size of the painting.

The scene is drawn confidently in ink and extensive notes have been added to record colour values and some of the forms. Comparing the sketch to the painting it can be seen that the colour notes have been carefully followed in the painting. Other notes in the form of numbers 1–5 or single letters a, b, c, relate to ranges of tone and hue values.

Harold Gilman 1876–1919

Canal Bridge, Flekkefjord c. 1913

Oil on canvas, 46 × 61 (18 × 24)
Tate Gallery 3684

The composition of the painting is slightly different from that of the sketch. The bridge is more centrally placed; features in the sketch to the right and bottom are lost, while the composition has been expanded on the left side and at the top. Clean, bright colours are consistently applied so that there is little change in handling between the areas representing sky, landscape, water or buildings. In the smaller forms the paint often does not cover the whole shape, leaving the drawing (executed in mauve oil paint) and the ground to show through. The final shapes of the colours were determined by the application of the paint rather than the initial drawing (ed Hackney 1982 p.79).

Frederick Lord Leighton 1830–1896

Helios and Rhodos

Oil on unstretched canvas, 21 × 14 (8¼ × 5½)
Private collection

Harold Gilman *Canal Bridge, Flekkefjord c.1913*

The colour sketch fulfilled a crucial role in the execution of Leighton's major paintings. Having evolved, with some elaboration, the exact design of a composition, Leighton then rapidly executed a sketch in oil to indicate the main placing and harmonisation of the work's colours. He wrote of his own 'fanatic preference for colour' and confessed to being 'passionately fond of colour'. Certainly the directness of his colour sketches, executed with a freedom and spontaneity of response that are played down in the more emphatically composed finished works, bear him out in this respect.

The colour sketch for 'Helios and Rhodos' is particularly significant. The finished work was held to express most successfully his passion for colour – 'Had he *sometimes*, at all events, allowed his "fanatic preference" to have free play, more of his works might have glowed with the revelry in rich colour we find in the canvas of "Helios and Rhodos"' (Mrs Russell Barrington). This final version of the work was destroyed in the Thames flood of 1928, so the sketch is all that remains in testimony to the finest expression of the artist's intense response to colour.

Edward Lear 1812–1888

Galera 1842

Black chalk, watercolour and thin gouache on blue grey paper, 26.7 × 49 (10½ × 19¼)
Tate Gallery 2749

Lear frequently travelled abroad, and he recorded his journeys by sketching in pencil, crayon, pen and ink, and watercolour. These small drawings on paper used materials which were convenient for the traveller. They were notes or documents to remind him of a scene rather than finished paintings. He sketched on site in pencil accurately portraying the scene and sometimes made written notes directly on the paper, 'penning them out' later when he added the thin colour washes.

J.M.W. Turner 1775–1851

Goring Mill and Church c.1806–7

Oil on canvas, 85.5 × 116 (33¾ × 45¾)
Tate Gallery 2704

This oil sketch may well be one of a series painted out of doors. It is on linen canvas with a pale thinly applied ground. It seems that Turner began by outlining the trees and buildings with pencil (clearly visible in the outlines of the tree tops). He then painted in the sky with a blue wash followed by thicker white for the clouds, leaving the ground to be seen as sky through the trees. Most of the painting was applied with a brush but possibly he smoothed the smoke and low cloud on the right with a thumb or palette knife. In the landscape he mapped the colours and forms with flat washes of colour, using the paint so thinly that the brush marks are not visible. As a preparatory

Edward Lear *Galera* 1842

J.M.W. Turner *Goring Mill and Church* c.1806–7

Sir Edwin Landseer *Loch Avon and the Cairngorm Mountains c.1833*

sketch it is probably complete even though he has not finished the cows and the foreground. Turner often returned to his oil sketches, developing them to a more finished state suitable for exhibition (ed. Hackney 1982 p.43).

Sir Edwin Landseer 1802–1873

Loch Avon and the Cairngorm Mountains c.1833

Oil on panel, 35.3 × 44.5 ($13\frac{7}{8}$ × $17\frac{1}{2}$)
Tate Gallery 5777

This straightforward sketch by Landseer is almost finished except for the right foreground which can easily be read as a beach. Here we can see the exposed pale ochre coloured oil ground. The paint layers have been brushed thinly and confidently with little or no reworking. The depiction of clouds and changing Scottish weather give this painting an immediacy which suggests that it may have been painted directly from nature. It is on a small panel which could have been carried comfortably by Landseer on a trip to the Highlands.

Note: panels of this size provide suitable supports on which to paint. Larger panels may involve joining two or more pieces. If they are constricted, their movement in response to humidity changes can sometimes cause cracks and splits to occur.

John Constable 1776–1837

Dedham Lock and Mill c.1819

Oil on canvas, 54.6 × 76.5 ($21\frac{1}{2}$ × $30\frac{1}{8}$)
Tate Gallery 2661

This oil painting shows the use of a brown ground. A dark ground enables the artist to develop shadows and to model his figures with greater ease. Dark or mid-grounds were popular for painting in *chiaroscuro* but began to lose favour towards the end of the eighteenth century, particularly in England, where they were replaced by lighter grounds. These have remained popular until the present day.

Constable frequently used a brown ground. This can easily be discerned in many of his paintings under the clouds and skies. In the landscape on this painting, the modelling of the trees has been executed by applying paint in thin layers directly onto the brown ground. The highlights and sky were applied more thickly so that the opaque white would obliterate parts of the dark ground. In general, since most paint layers are not completely opaque, a dark ground affects the overall tone and hue of a painting, so that light passages are generally reduced in tone, and thinly painted colours tend to be cooler in hue. In this case the brown colour of the ground compensates to some extent for the cooling effect. Many paintings on dark grounds have become darker than was originally intended by the artist, because the transparency of the paint film has increased, allowing the dark ground to show through more.

John Constable *Dedham Lock and Mill* *c.*1819

Constable also used light grounds; for instance, a mushroom-coloured ground in 'Flatford Mill'. The result is quite different and gives a much more intense and brilliant effect of sunshine, a property later exploited by the Pre-Raphaelites and the Impressionists, who used white grounds (ed. Hackney 1982 p.34).

Frederic George Stephens
1828–1907

Mother and Child c.1854

Oil on canvas, 47 × 64 (18½ × 25¼)
Tate Gallery 4634

Stephens was a founder member of the Pre-Raphaelite brotherhood. He worked with them for about four years before abandoning painting in favour of art criticism. The painting is on a medium weight linen canvas, with two layers of ground, a coarser yellowish white ground covered by his own smooth white lead layer. He painted with a fine brush, using bright colours thinly applied, often in glazes. Like other Pre-Raphaelites he would finish the painting of one area, and then move to another, working round finished areas. For instance, he painted the girl's white frock round the doll's red ribbon.

In contrast to the Constable, the white ground has enabled him to take advantage of the brilliant colours available at that time. An unmixed glaze applied over a white surface reflects the maximum proportion of any particular hue.

He may have prepared his paints himself with resin and oil as a medium, thinned with turpentine, testing them on the spandrels before using them in the composition. Rose madder has probably been used for the bright pinks, the purple may be cobalt violet, the greens emerald, the blues Prussian, and the bright yellow is almost certainly cadmium.

The perspective lines from the mantelpiece into the left spandrel are carefully annotated, but there are many inaccuracies in the rendering of some details. For example the incorrect drawing of the skirting board and the foreshortening of the child's left arm show that he found perspective difficult (ed. Hackney 1982 p.44).

Ford Madox Brown 1821–1893

'Take Your Son, Sir' 1851–92

Oil on seven pieces of paper, laid down on canvas, 70.5 × 38 (27¾ × 15)
Tate Gallery 4429

Like F. G. Stephens and other Pre-Raphaelite Brothers, Ford Madox Brown used supports primed with lead white, and painted with small brushes using quite pure colours and a lot of medium, keeping his paint layers thin. He tended to finish one area before starting another and, if his diary is to be believed, he worked very slowly.

Brown changed his mind about the size of this painting and the nature of the composition.

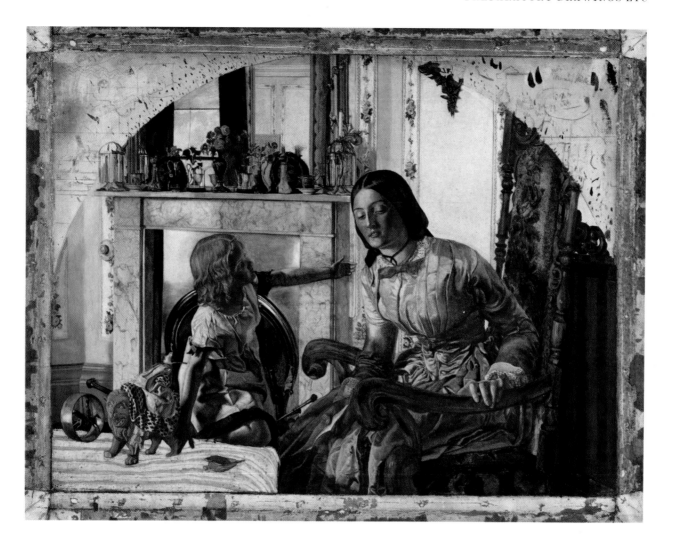

Frederic George Stephens *Mother and Child c.1854*

Ford Maddox Brown *'Take your Son Sir'* 1851–92

The support is seven pieces of canvas backed paper, all mounted onto one other piece of canvas. Brown's diary indicates that it was enlarged from a head and shoulders portrait of his wife, Emma, using three pieces of paper on canvas with a more pronounced weave, and then again with three pieces on smoother canvas. These pieces are clearly distinguishable in raking light, as are the alterations to the paint layers that Brown effected by scraping off the paint before reworking the area (ed. Hackney 1982 p.46).

John Singer Sargent 1856–1925
Study of Madame Gautreau
Oil on canvas, 206.5 × 108 ($81\frac{1}{4}$ × $42\frac{1}{2}$)
Tate Gallery 4102

This painting is an unfinished second version of the portrait of Madame Gautreau (known as 'Madame X', exhibited at the Paris Salon of 1884 and now in the Metropolitan Museum, New York). Sargent experienced some difficulties with its execution, and despite many preparatory drawings he reworked several areas of the painting. His reputation was for dashingly sure execution, so perhaps he felt the painting was overworked. At a late stage he started again on a canvas identical in size, fine weave and off-white ground, copying the first portrait. However this second version was not completed in time for the Salon, so 'Madame X' was exhibited.

Sargent started this painting with a thin

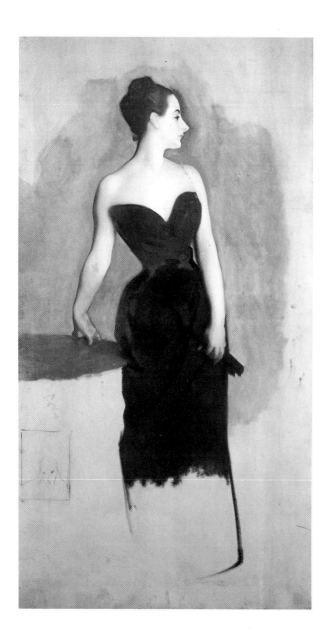

John Singer Sargent *Study of Madame Gautreau*

wash for the background and then mapped in the figure in flat areas of colour. In the face and neck it is this brown underpainting that forms many of the shadows, enhanced by the texture of the ground showing through this thin layer. The hair and features were painted in at this stage, and then the lavender scumbles, the highlights on the jaw and neck, the shadows on her left shoulder, the shaping of her bosom and arms were all modelled in thicker and denser paint. Where Sargent changed an outline he re-painted the background over the alteration to neaten the edge. Had he continued the painting such differences in density would have been covered, as would the unexplained sketch in the lower left corner, and the dabs and splashes of paint (ed. Hackney 1982 p.49).

Paul Gauguin 1848–1903

Tahitians c.1891

Oil and charcoal on paper, 85.5 × 102 ($33\frac{5}{8}$ × $40\frac{1}{8}$)
Tate Gallery 3167

'Tahitians' by Paul Gauguin is dated as *c*.1891 early in his first stay in Tahiti. It illustrates several aspects of the artist's techniques, and the development of this work can be read from right to left.

Works in oil on paper by Gauguin are rare. The study for the finished canvas 'Houses in the Country', signed and dated 1874, is the only other recorded oil study on paper. While Gauguin was in Tahiti he painted consistently

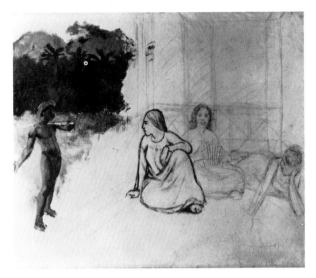

Paul Gauguin *The Tahitians* c.1891

on Burlap canvas. 'Tahitians' could well be an unfinished study on paper for a painting on canvas which was either lost or never carried out.

The composition has first been sketched sparingly in charcoal, and then the outlines have been defined by strengthening in blue (probably Prussian blue) oil paint using a stiff bristle brush. Next the artist began to paint the sky, background, landscape and the male figure before abandoning the sketch. At this painting stage, Gauguin has also moved the position of the male figure. The charcoal outline of the feet and legs can be seen to the right of the painted figure.

The long fibres of the paper indicate that it is a good quality rag, flax or mulberry paper probably bought in Paris. The present mounting on board and blind pine stretcher is much later than the drawing.

Oil painting

In this section there are examples of the use of drying oil as a painting medium. They show a variety of effects which can be produced by different methods of applying the same medium. These are in addition to the more traditional oil painting techniques which are represented elsewhere in the exhibition.

Degas has used a fine brush and restrained technique in his painting of 'Pellegrini'. O'Conor has applied his paint generously with a stiff bristle brush. Ernst has used a *frottage* technique to achieve textural effects, and Pollock has dripped liquid paint in continuous tracks across the ground. Each application has its advantages and limitations but all show imaginative use of essentially the same material.

Edgar Degas 1834–1917

*Carlo Pellegrini c.*1876–7

Oil on light grey paper, stuck on to a wood pulp board, 63.2 × 34 (24⅞ × 13⅜)
Tate Gallery 3157

Carlo Pellegrini, the well-known portrait caricaturist was born in Capua in 1839. Degas'

Edgar Degas *Carlo Pellegrini c.*1876–7

portrait of him resembles Pellegrini's contributions to *Vanity Fair* in its narrow upright format and the use of the rather amusing characterising silhouette.

It is painted in oil directly onto light grey paper. This is not recommended because excess oil can stain paper and spoil its reflective properties, making it yellow and brittle. Nevertheless, if the oil paint is dried on blotting paper before use, and applied sparingly in thin washes which have been diluted with turpentine or white spirit, it can produce very successful results. Under these conditions high quality paper provides an adequate support for small paintings, and there are none of the cracking problems associated with stretched canvas or wood, although some deadening of tone is inevitable as the medium sinks into the paper. Because of the lean paint and absorbent paper the surface of the painting is quite matt and could be mistaken for gouache. The thicker paint, however, retains a little gloss.

Note: Alterations to the background near the arm and coat tail, now look heavy and opaque.

Roderic O'Conor 1860–1940

Yellow Landscape, Pont Aven 1892

Oil on canvas, 67.7 × 91.7 ($26\frac{5}{8}$ × $36\frac{1}{2}$)
Tate Gallery T.2113

O'Conor spent much of his time in Pont-Aven working with other members of Gauguin's

circle. He was also influenced by the work of Van Gogh. In this work, the paint has been used expressively, building up 'impasto' to give a strong textural effect. The application of bands of saturated colour sometimes juxtaposed with their complementary or other contrasting colours provide a further interesting effect. The paint has been applied very thickly in broad, rhythmical strokes. Many of the colours are virtually straight from the tube; they have been neither mixed nor thinned with turpentine. Instead, they have been brushed, using a well loaded bristle brush, onto a white ground, (the colour of the ground is not very important since it has little effect through such thick paint).

The support is under tremendous strain from the weight of paint, revealed by the distortion in plane of the canvas and the cracking of the paint.

The painting is unvarnished so some of the paint surface is now more matt and dead than it was originally. However the painting was not intended to be varnished and to 'wet' it would alter the colour and tonal relationships as well as the surface texture.

Max Ernst 1891–1976

La Ville Entière 1935

Oil on canvas (*frottage*), 50 × 61.5 ($19\frac{3}{4}$ × $24\frac{1}{8}$)
Tate Gallery 5289

Roderic O'Conor *Yellow Landscape, Pont Aven* **1892**

Max Ernst *La Ville Entière* 1935

This is one of the most developed of a series of about a dozen paintings on the theme which Ernst began in 1935, and which culminated in two large pictures of 1936–7 called 'La Ville Entière'. One in in the Guggenheim Foundation in Venice and the other in a private collection in Paris.

In this technique called *frottage*, paper is pressed down onto a textured surface, and colour is rubbed onto the paper so that it picks up the pattern of the textured surface below. Here black paint quite rich in medium has been scraped over the paper, with variously: diamond, chequer board and plant forms underneath. The paper has then been stuck down onto a commercially prepared canvas. Also of interest the 'moon' (top left) has been drawn using a compass emphasising the automatic and mechanical nature of this work.

Jackson Pollock 1912–1956

No.23 1948

'Enamel' on gesso on paper,
57.5×78.5 ($22\frac{5}{8} \times 30\frac{7}{8}$)
Tate Gallery T.384

Pollock's 'enamel' is household gloss paints made with oil or alkyd resin. This has the advantage of being formulated to flow freely when applied straight from the tin. The paper has been coated with a lean white gesso to act as a reflective surface and also to protect the paper from the oil.

Pollock has used his 'drip technique', which involved laying the prepared paper flat on the floor and allowing continuous tracks of fluid paint to run onto it from the end of a brush or stick held over the work. He also used a basting syringe to obtain these thin continuous lines. The slight spread of white into the grey-blacks could be explained by the use of a wet ground.

Incidentally, fragments of a winged insect are embedded in the paint towards the upper right. The paint would have taken some time to dry since it has been applied more thickly than it was designed to be, so there would have been ample time for an insect to be trapped.

Jackson Pollock *No.23* **1948**

Other media

Not all painting is in oil or watercolour, there are many other media which can be used to adhere pigment to a support. Ideal media have good wetting properties, are transparent and colourless, and can be applied as a viscous liquid or be thinned to a low viscosity. Their optical and mechanical properties are often quite varied, so techniques for using them must be modified to suit each medium. However in general all media should be applied sparingly to gain the most value from the pigments.

Maxwell Armfield 1881–1972

This England – Portrait of an Owner 1943

Tempera on paper, 39.3 × 39.7 (15$\frac{1}{2}$ × 15$\frac{5}{8}$)
Tate Gallery T.1975

There is a long history of painting in tempera. The finest exponents of this technique during the Renaissance in Italy were admired by William Blake and his followers. Throughout the nineteenth and twentieth century groups of

artists have maintained the tempera tradition. In this painting egg medium has been applied as recommended in Armfield's *Manual of Tempera Painting* published in 1930. The tempera has been applied thinly using very little white and allowing the paper to reflect through in the manner of watercolour. Flesh colour has been built up over terre-verte underpainting in the Italian manner as recommended by Cennini.

Since egg medium dries quickly the brush strokes barely fuse on the paper. Armfield took advantage of this to exploit the effect achieved by juxtaposing strong colours employing a stippling technique, or by overlaying one thin-coloured wash on top of another. In this way he could maintain the purity of each colour and avoid the reduction in tone on mixing them. He had an impressive collection of pigments which he liked to use in isolation for maximum effect. An example of this is the purple madder used for the roses (ed. Hackney 1982 p.87).

Peter Blake b.1932

The Masked Zebra Kid 1965

Acrylic, enamel, collage on hardboard and wood, 55 × 22 × 3.2 (21$\frac{3}{4}$ × 10$\frac{1}{2}$ × 1$\frac{1}{2}$)
Tate Gallery T.1877

This work is an assemblage of a variety of materials including photographs, embroidery, acrylic and gloss enamel paint on plywood and hardboard.

The photographs are adhered to green baize

Maxwell Armfield *This England – Portrait of an Owner* 1943

Peter Blake *The Masked Zebra Kid* 1965

Morris Louis *Partition* 1962

supported on hardboard. Also on the baize are the Zebra Kid's autograph and a photograph which has been embroidered by Jan Haworth. The black frame and red horizontal piece are in household enamel gloss. The zebra fixed to the top is an old toy.

The acrylic painting on the top half of the composition was brushed directly onto the brown thinly primed plywood using the relatively dark surface as the ground. This gave it a dull tone which has been further toned down to be consistent with the collage material. The photographs and newsprint paper were old and to some extent deteriorated when first used by the artist. Blake chose them because he was interested in this particular quality, and he accepts that they will continue to deteriorate slowly.

The frame was added for protection (ed. Hackney 1982 p. 104).

Morris Louis 1912–1962

Partition 1962

Acrylic on cotton duck, 44.5 × 295.5 ($17\frac{1}{2}$ × $102\frac{1}{4}$)
Tate Gallery T.803

This is one of Morris Louis' 'narrow stripe' paintings in acrylic medium on a cotton duck canvas. Most of the canvas is left unpainted, and the acrylic paint has been applied in a staining technique.

The acrylic used here is 'Magna', a white spirit soluble, oil compatible medium. It should not be confused with acrylic medium in emulsion form, which can be thinned with water but becomes insoluble in water on drying.

In the staining technique the paint is applied directly to the unprimed canvas. Usually it is absorbed and spreads through the fibres by capillary attraction producing a soft edge. A stain does not have the same reflective properties as a glaze or a scumble applied on top of a white ground. Except for the most opaque pigments the colour and tonal values of the stain are always lower.

Louis probably chose to paint on cotton duck because it has an absorbent brushed surface and because it was available in large sizes.

Watercolour and gouache

This section is concerned with techniques employing water soluble gums as the medium. The traditional transparent watercolour technique of applying washes thinly on a light-coloured ground is contrasted with the gouache technique involving opaque pigments. But within these broad terms there are a variety of possible applications, some of which are illustrated here.

John Sell Cotman 1782–1842

Norwich Market Place 1806

Watercolour on paper, 40.6 × 64.8 (16 × 25½)
Tate Gallery 5636

This work by Cotman is an example of illustrative watercolouring at its best. The drawing is in pencil on paper and would have been executed in front of the scene. In this case the perspective suggests that the artist was at a first floor window. The drawing is probably quite an accurate representation of the buildings and contains a reasonable amount of detail in the foreground figures.

It was then taken back to the studio to be coloured in flat washes of watercolour. This washing was of particular interest to Cotman who readily identified the artistic possibilities. But other artists often left colouring to their assistants. For example, both Turner and Girtin were trained to paint by colouring prints and drawings.

In this painting the pattern of colours and tones is extremely well contrived. The grey flat shadows and stylised sky add to the effect.

Thomas Girtin 1775–1802

Bamburgh Castle c.1797–9

Watercolour, 54.9 × 45.1 (21⅝ × 17¾)
Tate Gallery 4409

Girtin painted in the topographical tradition but he was one of the first artists to colour his drawings in front of the subject matter. Because of this he had the opportunity to portray changing patterns of light and atmospheric effects. He rose to this challenge and in addition he explored the use of washes of subdued watercolour, to model the shadows which defined his forms. He continued to apply the medium in the traditional way, in thin washes which allowed the paper to show through, but he chose to paint on a warm-coloured cartridge paper. This paper toned down his applied colours but allowed more scope for modelling with shadows. For details and small highlights such as the seagulls he has

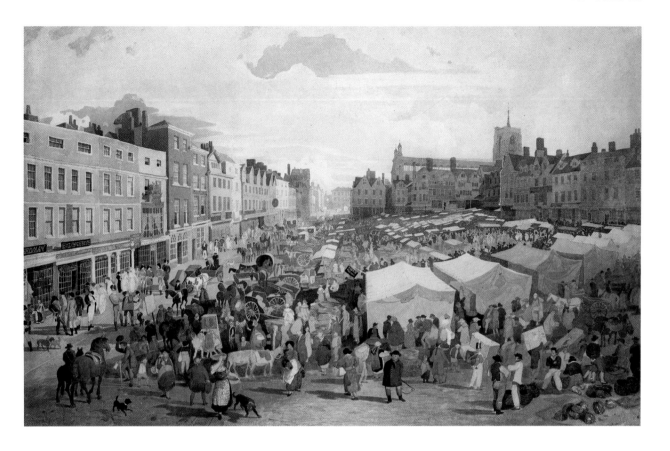

John Sell Cotman *Norwich Market Place* 1806

Thomas Girtin
Bamburgh Castle c.1797–9

William Henry Hunt *Primroses and Bird's Nest*

used an opaque white. This painting is a good example of Girtin's mature technique.

William Henry Hunt 1790–1864
Primroses and Bird's Nest
Watercolour on paper, 18.5 × 27.3 ($7\frac{1}{4}$ × $10\frac{3}{4}$)
Tate Gallery 3564

Hunt has applied a zinc white ground to the paper enabling him to paint in watercolour in a similar manner to the Pre-Raphaelite technique in oil. He has defined the shadows in dark earth and brown colours and built up the highlights in several relatively thick layers of opaque white paint. The painting is very precisely executed and detailed.

The colours have been applied by hatching and dabbing using a small brush. Wherever possible he has chosen transparent pigments for glazing or otherwise he has used very thin scumbles. He has either placed one pure colour on top of another or two colours in small dabs close together so that they merge when viewed from a distance. This avoids mixing and preserves the luminous effect of the individual colours placed over a white ground.

Note: the blue shadows on the leaves seem to indicate sunlight. On a sunny day objects cast cool shadows because of the bluish diffuse light reflected from the sky onto the areas of shadow. This contrasts with the areas illuminated by yellow sunlight.

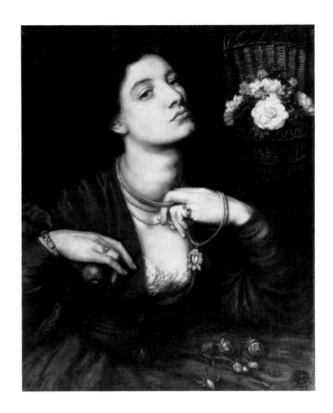

Dante Gabriel Rossetti 1828–1882
Monna Pomona 1864
Watercolour and gouache on paper,
46.0 × 37.8 ($18\frac{1}{8}$ × $14\frac{7}{8}$)
Tate Gallery 2685

This painting is in watercolour yet Rossetti has attempted to treat his medium as though it were oil.

Beginning with an off-white, machine-made paper he has applied the watercolour extremely thickly in successive layers. The highlights and

areas such as the dress are in the almost completely opaque gouache technique. The shadows are thick and dark, but transparent, with a glossy surface owing to excess gum mixed with the brown. Tiny cracks are evident in the browns, this shows that Rossetti has exceeded the limitations of the medium. The flesh tones are scumbled less thickly onto the paper.

The frame is original. The outer part is carved wood and the inner piece is moulded in whiting and size. The texture of the wood grain is visible on the flat portion. Gold leaf has been applied to the entire front surface of the frame.

Edward Burra 1905–1976

Harlem 1934

Ink and gouache on paper,
79.4 × 57.2 (31¼ × 22½)
Tate Gallery 5004

This is a modern example of gouache on white paper. The design has been drawn quite precisely in black ink, using a ruler in places. The paint has been applied less thickly than in the Rossetti but with a similar effect. The colour of the paper is hardly important and highlights have been executed using white opaque paint.

Although quite opaque, it is still possible to see the figure on the left which has been painted out. Gouache can sometimes be applied safely

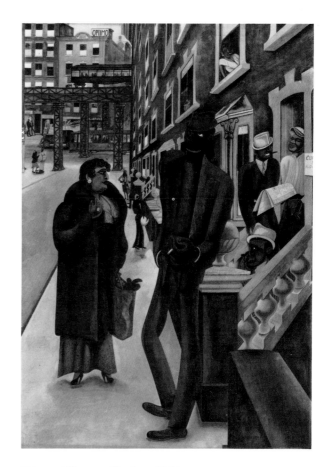

Edward Burra *Harlem* 1934

over ink but where the black ink has been applied over a layer of paint, for instance, on the woman's eye and hair, the two films are separating and cracking.

Bibliography

Beal, M.,
'Richard Symonds' Note Books', PhD Thesis Courtauld Institute of Art, London, 1978.

Bristow, I.,
'Ready Mixed Paint in the Eighteenth Century', *Architectural Review*, April, 1977, p.247ff.

Colour Index
Society of Dyers and Colourists, Bradford, Yorkshire, and American Association of Textile Chemists and Colourists, Lowell, Mass. 4 vols, 2nd edn 1956.

Constable, W. G.,
The Painter's Workshop, London 1954.

Diderot, D., & D'Alembert, J.,
Encyclopédie : ou diction- naire raissoné des sciences, des arts et des métiers 17 vols Paris and Neuchâtel 1754–63 reprinted New York, 1966.

Doerner, M.,
The Materials of the Artist and their Use in Painting, London 1953.

Eastlake, Sir. C.,
Materials for a History of Oil Painting, London 1847, 1869. Reprinted as *Methods and Materials of the Great Schools of Painting*, New York 1960.

Field, G., *Chromatography, or a Treatise on Colours and Pigments, and of their Powers in Painting etc.*, London 1869; also ed. Thomas W. Salter, London 1869; and ed. C. J. Scott Taylor, London 1885.

Gettens, R. J. & Stout, G. L., *Painting Materials: A Short Encyclopaedia*, New York 1942; reprinted 1966.

Graff, van de J. A., *Het de Mayerne Manuscript als Bron voor de Schildertechniek van de Barok* Mijdrecht, 1958.

Ed. Hackney, S., *Completing the Picture. The Materials and Techniques of Twenty-six Paintings in the Tate Gallery*, London 1982.

Harley, R. D., *Artists' Pigments 1600–1835*, London 1970.

Harley, R. D., 'Oil Colour Containers: Development Work by Artists and Colourmen in the Nineteenth Century', *Annals of Science*, vol 27 N.I., March 1971.

Harley, R. D., 'Artists' Brushes: Historical Evidence from the Sixteenth to the Nineteenth Centuries', *International Institute for Conservation Lisbon*

Congress 1972: Conservation of Paintings and the Graphic Arts, London 1976.

Harrison, A. W. C., *The Manufacture of Lakes and Precipitated Pigments*, ed. J. S. Remington & N. F. Francis, London, 2nd edn, 1957.

Laurie, A. P., *The Pigments & Mediums of the Old Masters*, London 1914.

Mayer, R., *The Artists' Handbook of Materials & Techniques*, New York and London 1970

Merrimée, M. F. F. L., *The Art of Painting in Oil, and in Fresco*, London 1839.

Merrifield, M. P., *Original Treatises dating from the XIIth to XVIIth Centuries on the Arts of Painting*, 2 vols, London 1849. Reprinted New York 1967.

Thompson, D. V., *Cennino Cennino: The Craftsman's Handbook*, translated by Thompson, Yale 1933.

Thompson, D. V., *Materials and Techniques of Medieval Painting*, New York, 1936, reprinted 1956.

List of contributors

A GUIDE TO THE HISTORY OF PIGMENTS
Peter Staples

THE MANUFACTURE OF ARTISTS' COLOUR
Peter Staples

PERMANENCE
'Mary Magdelene Reading'
Caroline Villiers
'Scenes from the Life of a Bishop'
Isabel Horovitz

ARTISTS AT WORK
'Monet painting at the Edge of a Wood'
John House

ARTISTS' EQUIPMENT
Brushes
Mary Beal
Canvas
Caroline Villiers

PAINT MEDIA
Nick Eastaugh

PREPARATORY DRAWINGS, SKETCHES AND UNFINISHED WORK
'Helios and Rhodos'
Ben Read

Photographic credits
*Janet Balmford, Chris Steele-Perkins, John Webb,
Prudence Cumming Associates,
Courtauld Institute Photographic Department*